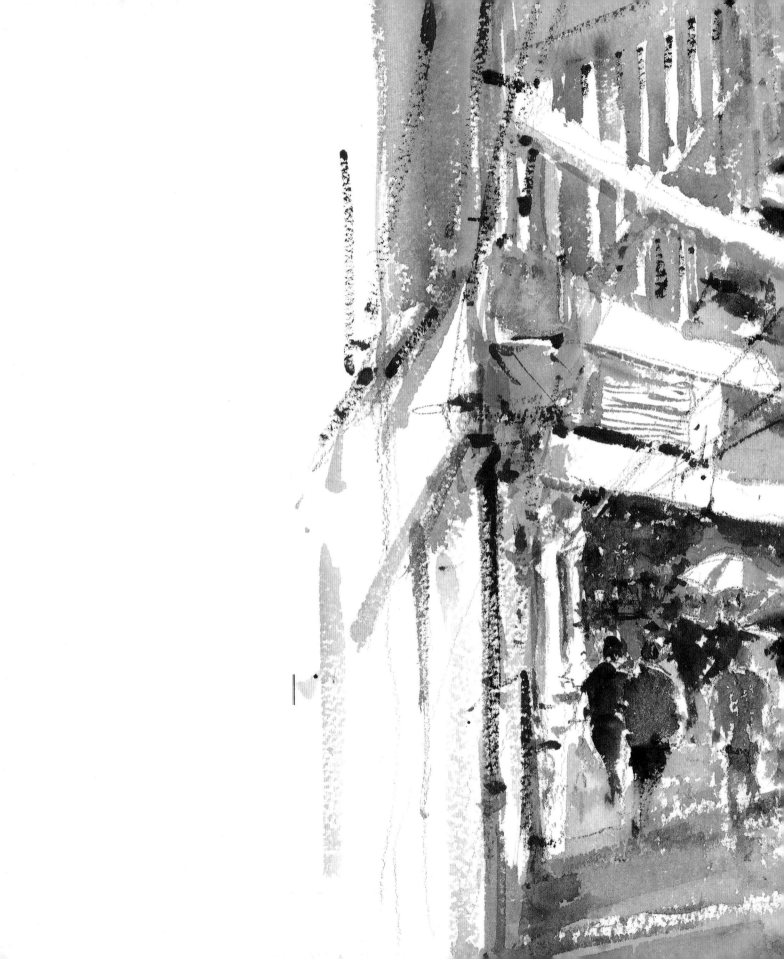

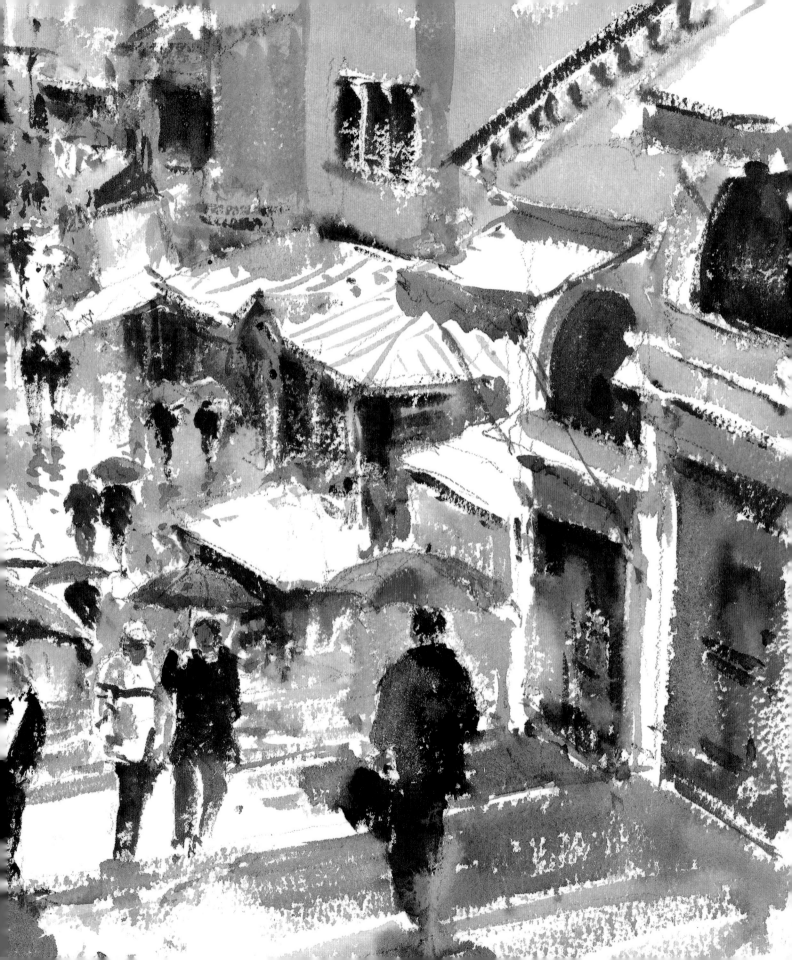

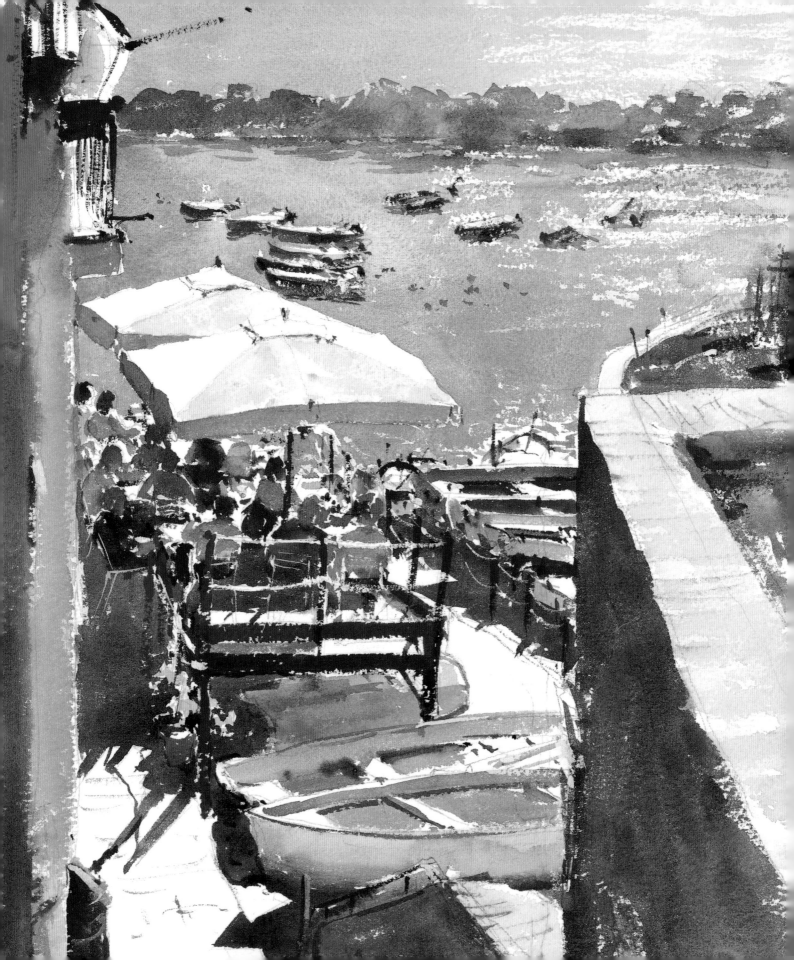

The Artist's Essential Guide to

Watercolour

Gerald Green

D&C
David and Charles

Cover
Woman in Feather Hat
30 x 42cm (12 x 16½in) on 225gsm cartridge paper

Preface image
Rio Maggiore
40 x 30cm (16 x 12in) on 300gsm Rough surface Arches paper

'Hundreds of people can talk for one
who can think, but thousands think
for one who can see.'

(John Ruskin, Modern Painters, *Vol. III, Part IV, Chapter 16,
Section 28, published in 1856)*

Contents

Introduction

The aims and objectives of this book are simple, precise and direct: to offer an alternative practical approach to using watercolour; to help you negotiate your way around its difficulties and uncertainties, and to enable you to develop a freer, more expressive, less laboured way of painting.

About the medium

Watercolour is a somewhat deceptive medium: it looks simple, but it isn't. Some artists even suggest that it is the most difficult painting medium of all. I am not going to pretend that watercolour painting is easy; no matter what your level of experience, it offers few certainties. It may be challenging, but the potential rewards are immense, because watercolour has the capacity to produce breathtaking results. Success lies in the realization that it can be brought to life only by gentle persuasion, rather than attempting to force it beyond its natural capabilities. We must therefore first get to know its idiosyncrasies and then learn to work within its limitations. The process of painting is then a delicate balance between exercising just enough control, on the one hand, and 'letting go', on the other, so the medium does what we want it to, while at the same time, we allow it the freedom to behave naturally.

Riverside
30 x 40cm
(12 x 16in)
on 300gsm
Rough surface
Arches paper

About the book

My general philosophy in this book is to show you how to use watercolour to capture the essence of your subjects with greater informality. Using a direct way of painting, I illustrate how to create impressions, rather than photographic likenesses, suggesting elements in a loose, understated way, rather than attempting to depict them with meticulous detail. This allows the immediacy and spontaneity of the medium to come through and gives paintings greater vitality. Throughout the book, I use worked examples to explain how best to use the medium to achieve these results.

I reveal how underlying key principles can be used more effectively to enliven images, together with how to add impact with design. I also examine alternative ways of portraying light, with additional suggestions for furthering personal expression.

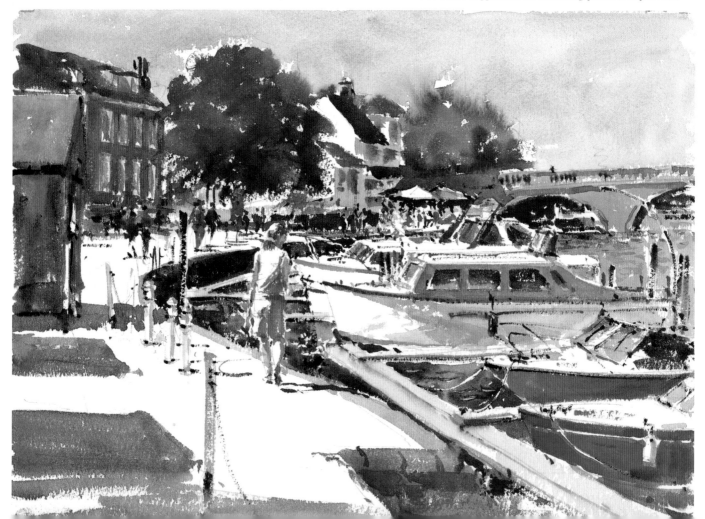

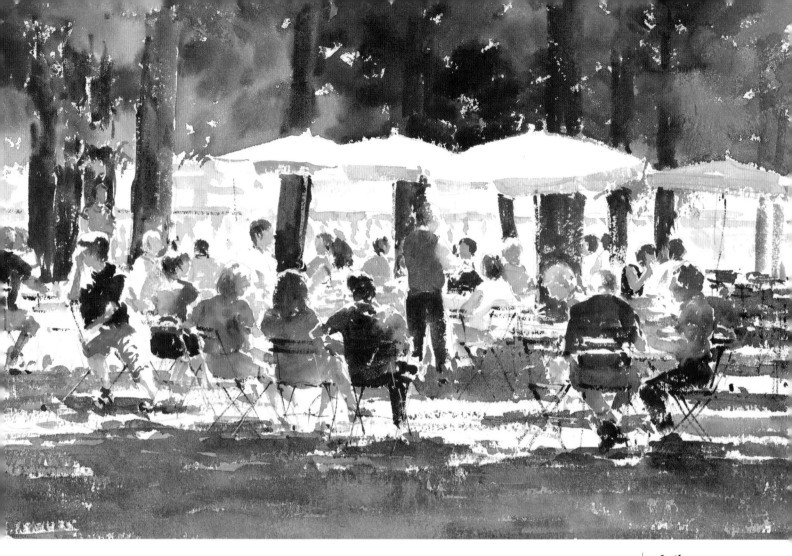

The creative triad

There are three key principles that underpin my approach: simplicity, precision and directness. These together form a powerful creative triad:

Simplicity – means reducing subjects to their essentials and is always the most important course of action
Precision – denotes accuracy in interpreting what is seen, although this does not imply elaboration
Directness – describes the way of applying the medium in a decisive, thoughtful and considered manner.

Together, these characteristics add up to more than the sum of their parts; they offer the gateway to increased freedom of expression throughout all areas of the painting process. They can also be used for other painting media.

Consider these principles each as one side of an equilateral triangle. Each one is equally as important as the others; each one requires the remaining two for stability; and either combination of two requires the third to fully bring them to fruition. Paintings need to have a measure of all three components in order to portray a sense of vitality and freedom of expression. For example, precisely drawn, simplified subjects need to be painted in a direct way to maximize impact. Alternatively, simplified subjects, painted in a direct way, will have greater clarity when combined with precise drawing. Directly painted, precisely drawn images also need to be simplified in order to catch the essence of a subject.

In the
Luxembourg
Gardens
30 x 40cm (12 x 16in) on 300gsm Rough surface Arches paper

Discovering a natural way of expressing ourselves in paintings, which is best suited to our individual personalities, will be a continually evolving process. It will be influenced by personal response, ambition and inner drive, coupled with a general dissatisfaction with whatever we may be producing at any one time. Inevitably this will take us through many changes over a long period and the process must be allowed to happen naturally at its own pace, without being forced. To strive for a characteristic style or distinctive look in our paintings would ultimately deny us the opportunity to discover where our own creative potential might eventually lead us.

My approach to painting

In my opinion, watercolours should simply aim to catch the moment. Paintings should show the essence of the particular subject without overstatement or the appearance of being overlaboured, as if the paint has fallen naturally into all the right places. Although my aim is to try to recreate these qualities in my own paintings, achieving this with any degree of certainty is a lifetime's challenge.

Grande Harbour
30 x 40cm (12 x 16in) on 300gsm
Rough surface Arches paper

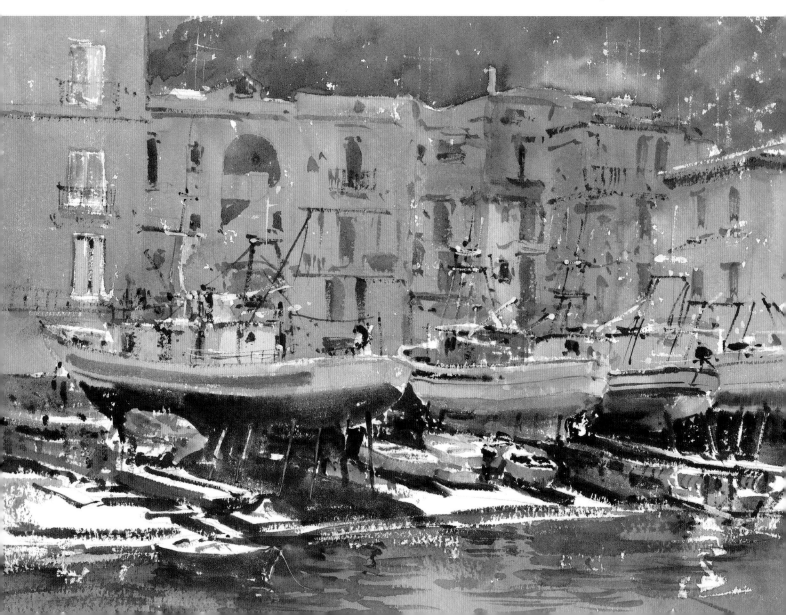

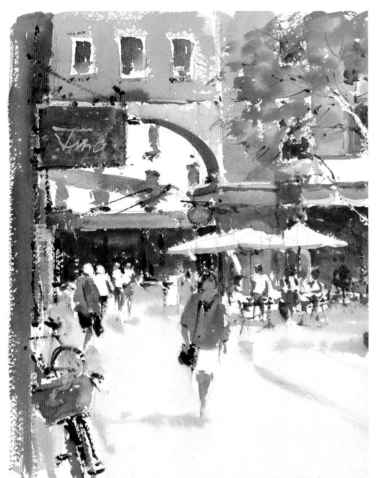

Strolling in Cambridge
25 x 19cm (10 x 7½in) on 300gsm
Rough surface Fabriano paper

Using the book

Whether you decide to go through the book in the order it is written, or dip into it looking for more specific points of interest, it is important to realize that you will not be able to solve all of your painting problems at once. Painting requires us to do many things all together – for example, thinking about form; tone and colour; space and composition; light and shade – while we are also actively engaged in trying to deal with the practicalities of applying the medium. This is rather like negotiating our way through busy traffic when driving, while at the same time having to combine watching the road, steering, checking the rear view mirror, changing gear with our hands, working the pedals with our feet, and so on. It is sometimes easy to feel overwhelmed and even, on occasions, as if progress has come to a standstill. The solution to seemingly unresolvable problems is first to take a step back to evaluate where you are, and then work at solving your immediate difficulties one step at a time.

Piccolo Player
29 x 40cm (11½ x 16in) on 250gsm Bristol Board

Most of my early attempts at painting outside using the more traditional wash-laying techniques ended in failure; I lost my motivation, owing to my irritation at having to wait around for what seemed endless amounts of time while washes were drying. For several years, therefore, I limited my outdoor activities to drawing and sketching, usually in pen, and often with the addition of pencil toning. When I again began to work outside with watercolour, I simplified the painting process to using two colours, usually brown and grey. I often painted on grey scrapbook paper, adding back my lights with white chalk. These works were produced ostensibly as informational images, which I worked from to produce more refined studio paintings. I produced the studio paintings in the traditional way, using a hairdryer to speed up the drying process. However, time and again, the studio paintings seemed to lack the vitality of the simpler, directly painted, on-the-spot work. Eventually, I opted to paint exclusively in the more direct manner. I now either complete paintings on the spot, or produce studio paintings that are worked up from on-the-spot drawings and photographs. Although my paintings are essentially figurative representations of the world around me, I try to present the viewer with something beyond just a faithful representation of the original scene.

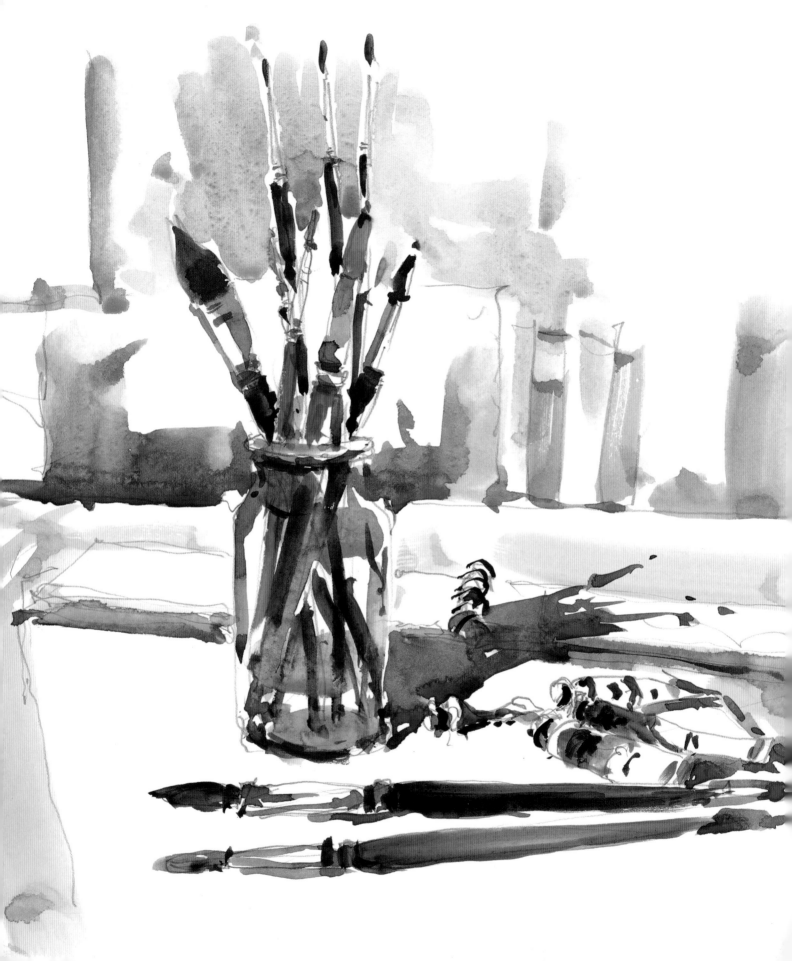

Chapter 1

Materials and Methods

Our materials are the instruments with which we turn our creative ideas into reality, so they must support our needs by being both reliable and comfortable to use. It is always good policy to buy the best you can afford and to remember to look after them well because they are a valuable resource. They are also probably the only real constant we have in painting.

Tools of the Trade
30 x 42cm (12 x 17in) on 200gsm Hot pressed Arches paper

Materials

You don't need a lot of equipment to paint well, so be selective
and simplify your materials to a few really good-quality items.

Palettes and paint

I use a range of metal Holbein palettes
in conjunction with Winsor & Newton
or Holbein Artists' Quality tube colours.
The large palette has twenty-four slots for
colours and generous mixing-well areas. I
find tube colours the most practical because
I can top up with fresh pigment at the start
of each painting session; this gives me
constant access to moist, workable paint.
There is nothing more likely to hinder
progress than trying to rewet dried-up areas
of colour on your palette.

For sketching, I also use a small Cotman
pochade box, which contains spaces for
twelve half-pan colours. This is useful when
I only have a pocket in which to carry my
materials.

Cadmium Red Pale
Cadmium Red
Cobalt Violet
Cadmium Orange
Caput Mortum Violet
Raw Umber
Burnt Umber
Sepia
Blue Black
Neutral Tint
Lamp Black
Prussian Blue
Indigo
Winsor Blue
Ultramarine Blue
Cobalt Blue
Cerulean Blue

Alizarin Crimson
Burnt Sienna
Light Red
Raw Sienna
Cadmium Yellow
Cadmium Lemon
Naples Yellow

*This is my large metal
Holbein folding
watercolour palette,
showing the colours I use*

Two French Ultramarine
small sponge
Indigo
Burnt Sienna
Light Red
Alizarin Crimson
Cerulean Blue
Winsor Blue
Raw Sienna
White
White Conté sticks
Cadmium Lemon
Lamp Black

*I use this pocket-sized Cotman pochade
box, with the colours shown, usually in
conjunction with an 18 x 13cm (7 x 5in)
toned paper watercolour sketchbook, when
carrying space is at a premium*

This selection of brushes caters for all my needs

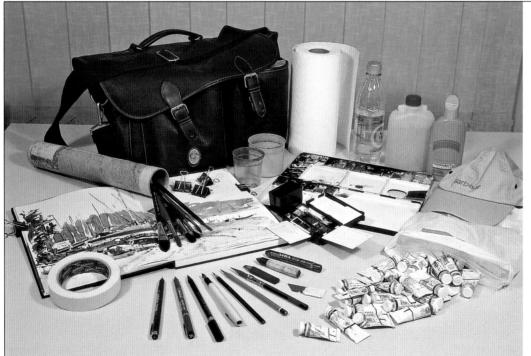

Brushes

My requirements for brushes are that they should be capable of holding a reasonable amount of paint, form a good point and be springy enough to return to their natural shape during use. I find Isabey series 6235 Petit Gris, squirrel hair, Da Vinci 5580, or Winsor & Newton Sceptre Gold sable synthetic brushes most suitable. These brushes are produced in a range of sizes and are capable of producing a variety of marks, from broader strokes to finer lines. I also carry a Japanese rigger, which is useful for adding in flicks of dry brush or very fine lines.

Paper

I use Rough or Not surface papers when I want lively textural effects, and Hot pressed papers where I want a more fluid look, as the medium tends to move around a little more. My preference is for Arches or Fabriano paper, which accept my method of painting without cockling. They also give back something in use, keeping colours fresh and vibrant without sinking. I buy paper in large sheets, which I cut down to make up my own painting pads in a variety of sizes. I favour using tinted watercolour paper, such as Bockingford or Two Rivers oatmeal, cream or grey, usually in combination with a limited colour palette. I also have a particular liking for painting on good-quality cartridge paper or Bristol Board. These papers' greatest asset is that they are so resistant to rewetting and alteration that they force me to be more positive in my approach. The results are like nothing I can achieve with any other paper and the runbacks can be spectacular. I have always found stretching paper far too bothersome, so I rarely do it.

Sketching

I am an advocate of regular sketching because drawing forms such an important part of the painting process. I prefer hardbacked sketchbooks since they facilitate working across adjacent pages. I like to draw in ink with an Osmiroid fillable sketch pen (regrettably no longer manufactured). I find the Edding 1800 Profipen or Staedtler Pigment Liner felt-tip pens most suitable for sketching, being both lightfast and waterproof. I also carry 2B, 4B and 6B pencils and a graphite stick, or flat, soft-leaded carpenter's pencils, which I find useful for blocking in areas of tone in combination with ink sketches.

Supplementary materials

I usually also carry a supply of kitchen roll, various bulldog clips for holding down sketchbook pages, drafting tape, blades for sharpening pencils, a sun hat and sun protection cream, which, together with my other materials, I carry in my sketching bag.

For convenience, it is best to reduce your materials to the essentials, which can then be easily carried around in a sketching bag or rucksack

Painting Methods

The position you adopt for painting will influence the look of your work. Whether you prefer to paint standing up, sitting down, at an easel, or at a table, it is essential to maintain unrestricted movement of the body.

Outdoor painting

Outside, we have to adapt to the uncertainties of a more varied environment, including changes in light, weather conditions, noise and possible interruptions from an unwanted audience, which for many can be a rather daunting experience. However, this added discomfort will force you to develop the means to work quickly and effectively, so I would urge you to overcome any misgivings – it is an exhilarating and fulfilling experience. Perhaps the worst conditions are dull days when there is a lot of moisture in the air, because then it is almost impossible for watercolours to dry completely. Under these circumstances, drawing may be your only option. I produced the painting right while sheltering under a tree from the rain. Alternatively, line and wash drawings, in which watercolour is used to tint or partially tint a drawing, can be used when painting time is short, or when you are in an inconvenient spot, as in the painting below.

In what I term 'hostile' places, it is best to limit your equipment to what you can hold; this will allow you to remain fairly inconspicuous. I have managed to paint undetected in cafés and even at music concerts, holding my pochade box and a small sketchpad in one hand.

Dartmouth Estuary
29 x 40cm (11½ x 16in) sketchbook study
Coping with changes in the weather is a fundamental part of painting outdoors. I produced this sketch on an overcast day, under the shelter of a convenient tree. The marks on the painting are spots of fine rain

Town Street
29 x 40cm (11½ x 16in) felt-tip pen and watercolour line and wash sketchbook study
When working outside, always be responsive to the unexpected. Initially intending to produce only a drawing, I took advantage of a sudden burst of sunlight; working with my materials in the boot of my car, I flooded in a rapid wash to record the light's effects, letting the colours run together on the paper

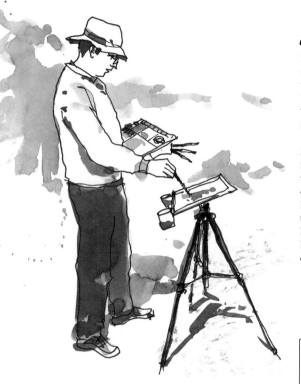

Standing to paint facilitates regularly stepping away from the work as it proceeds, while also allowing me the freedom to paint from the elbow rather than from the wrist

Easels

I prefer to work standing up. This has the advantage of enabling me to paint at arm's length, from the elbow rather than from the wrist, so I am less inclined to be fussy. It also enables me to step back frequently to observe my progress from a greater distance. This prevents me from becoming too focused on any single area in isolation.

My easel is a converted photographic tripod. It is light in weight, folds away compactly and fits easily into a medium-sized suitcase when travelling. It can be conveniently adjusted in height and offers the flexibility for setting the painting surface from a horizontal position to an angle of nearly 60 degrees. If I do have to resort to painting sitting down, the easel can be set at a lower level by reducing the extension of the legs. Alternatively, I simply lie my pad and materials on the ground, or against a convenient object, so I still have the freedom to paint at arm's length.

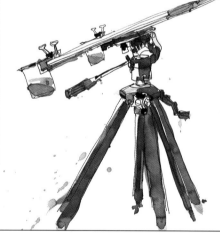

I paint on a detachable hardboard panel, which is secured to the tripod with a preformed wooden bracket. An L-shaped timber rail along the lower front edge of the panel acts as a support for my painting surface and for my two water pots. The pots are also secured in place with bulldog clips

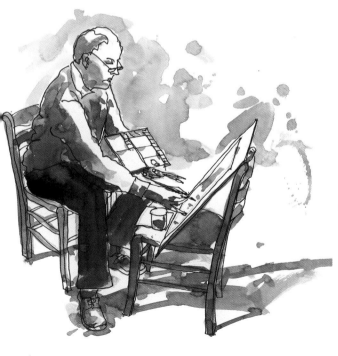

When sitting down to paint, a second chair serves as a convenient easel

Studio painting

At home, or in the studio, painting is generally a more controlled process; however, the danger here is that you can become too comfortable. I recommend that you resist the temptation to sit in a cosy chair or at a table, painting as if you were writing; this is more restrictive and will lead towards a tighter approach, with a resultant loss of freedom and spontaneity. To prevent this, I try to recreate some of the outdoor tension by adopting the same standing painting position, either using my tripod easel, or an oil painter's box easel, on which I often paint with my paper in a vertical position. On those occasions when I do sit down, I use a second chair as an easel, with my board resting on the seat and propped against the back at an angle of about 60 degrees.

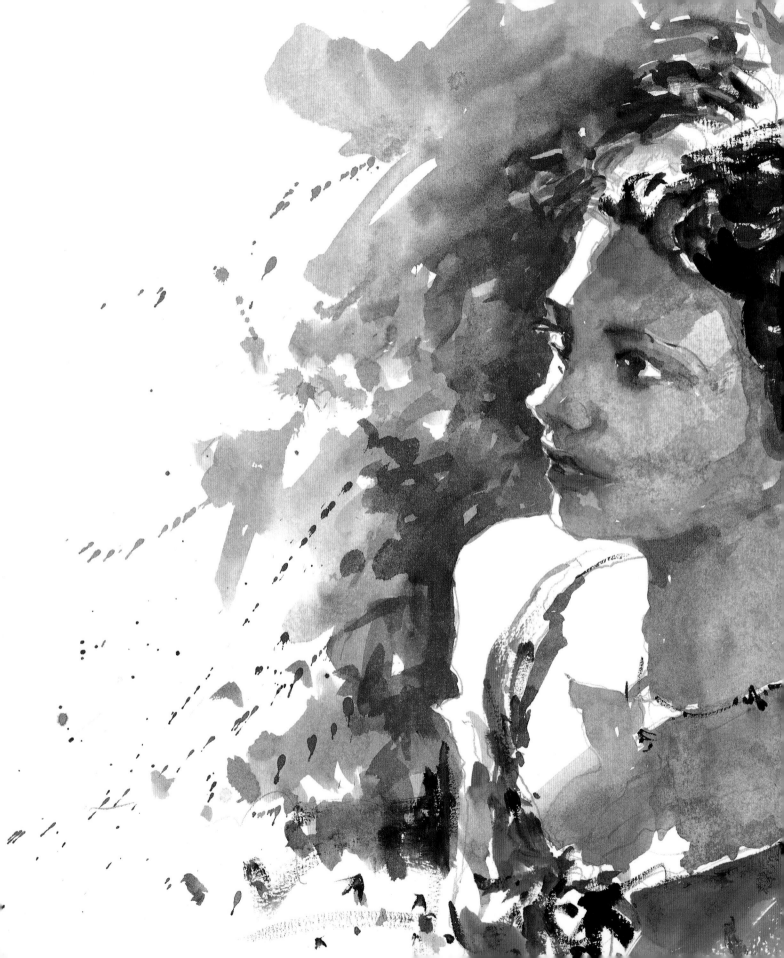

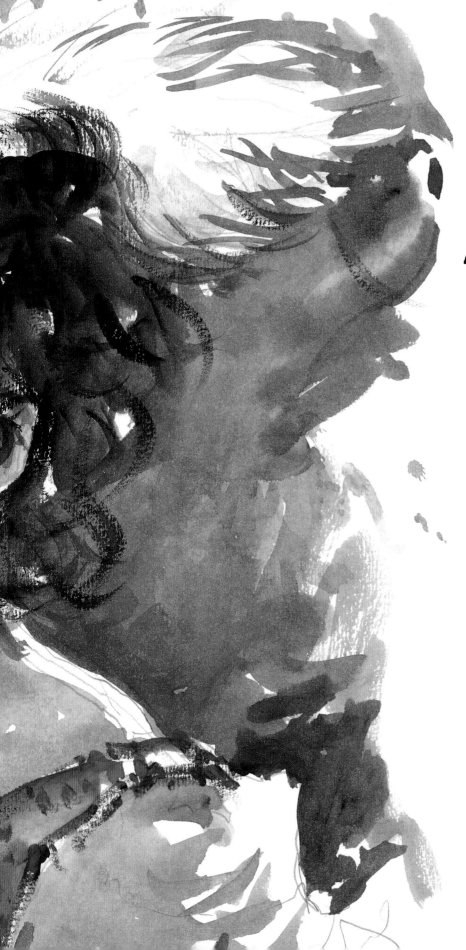

The Direct Approach

Compared to the more conventional watercolour painting methods, in which images are built up from separate overlayered washes of colour, traditionally working from light to dark, the principle aim of the direct approach is to 'get it right first time'. This minimizes the need for overpainting and therefore reduces the likelihood of overworking. It also helps to keep the medium fresh and lively.

Woman in Feather Hat
30 x 42cm (12 x 16½in) on 225gsm cartridge paper

The Vital Spark

Watercolour is an extremely versatile medium, with the capacity to produce both soft, ethereal lights and powerful, rich, velvety darks, but its greatest asset is its immediacy and spontaneity. To ignite this potential, it is necessary to strike a balance between exerting a degree of control and allowing the medium to be itself.

Using directness

How colour is applied is the main factor in watercolours retaining their freshness and appeal. Applying the medium with directness simply means laying in areas of colour precisely, in one go, either as single colours or as combinations of colours placed next to each other. You should resist the temptation to retouch or adjust them further. The more you attempt to push the medium beyond its natural capabilities, the greater the risk of overpowering it, with a resultant loss of vitality. In the painting right, my approach was to guide and coax the medium as I applied it, allowing it to blend, run on, or run back naturally as it dried.

Three Hats
20 x 29cm (8 x 11½in) on 300gsm Rough
surface Saunders paper
*Matching my colours to those in the subject,
I applied the medium with directness, placing
the objects in one at a time. It is advantageous
to include parts of the background as you go
along, as I did here, so that the entire image is
built up as a whole*

Laying colour

Laying colour is the first of three factors to consider when applying watercolour. You need to use exactly the right amount of water, so that your colour mixes flow in the way you want them to. If they are too watery, they will run away from you and bleed excessively into adjacent areas, as in the swatch below left. When too little water is used, drying time will be reduced and colours will remain harder-edged, as in the swatch below middle.

One of the most rewarding characteristics of watercolour is its capacity to be mixed on the paper, and a vital part of the direct approach is laying colours side by side, while wet, so that only their edges fuse together, as in the swatch below right. To prevent excessive bleeding, keep the water consistency of adjacent colours the same. You may find it helpful to test the behaviour of your mixes on a separate piece of paper before applying them.

Here, my three colours, Cadmium Red, Raw Sienna and Ultramarine Blue, contained too much water, so they completely overpowered one another, resulting in an uncontrollable puddle

Compared to the previous example, here I used too little water. The colours remain hard-edged and also appear darker, because they are less dilute

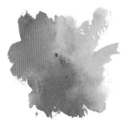

Compared to the two previous examples, here I used just enough water so that all three colours remained separate, while blending only at their edges. The only way to gauge the amount of water needed is by trial and error. You will eventually become accustomed to the feel of the right consistency of paint as you work it in your palette

Overlayering

The second requirement is judging the relative lightness or darkness (tonality) of your colours before applying them. Since watercolour is an inherently transparent medium, the more you overlay colour (for example, when overpainting to darken areas), the more you risk losing transparency and increase the probability of your colours becoming muddy or messy, as in the painting right.

Drying

The third, slightly more troublesome characteristic, is that watercolour becomes lighter as it dries, so you must consider this when applying it. Estimating the lightness or darkness of first applications of colour can be the most problematic part, since you will have only the paper itself (usually white) with which to compare them. This will naturally make first colour applications appear relatively darker than they actually are. A useful rule of thumb is that if colours appear tonally correct at this stage, they will more than likely be too light when the painting is finished. If they appear slightly too dark to begin with, they will probably look about right on completion.

Ponte del Pugni
15 x 20cm (6 x 8in) on 300gsm Rough surface Fabriano paper
The shaded foreground area in this image is overworked, resulting from overlayering too many colours. As the painting progressed, my initial application of three blended colours appeared too light, so I repeated the process, causing the colours to lose their sparkle and look dirty

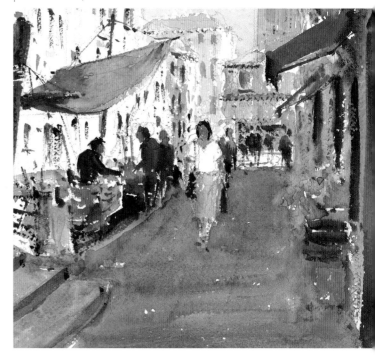

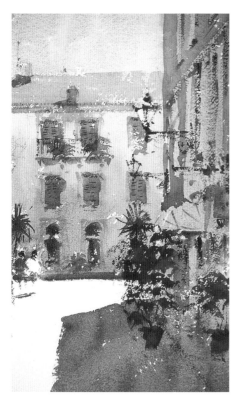

Sestri Levante
30 x 15cm (12 x 6in) on 640gsm Rough surface Arches paper
This is an example of effective overlayering. I coaxed out the forms on the right-hand building façade by overpainting around them with a slightly darker version of my original colour. I then reinforced some of the elements with additional drybrush drawing. Here, the limited amount of overpainting has not reduced the vitality in the colours

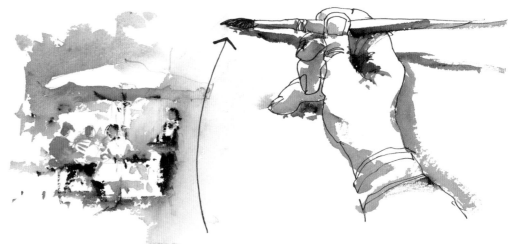

Another useful tip, ideally suited to watercolour, is that edges of still damp paint can be softened away. Take up a full brush of clean water and make one sweeping stroke along the paper, just clipping the still damp area to be softened. Colour will then seep into this wet area. Varying the amount of water on the brush will alter the extent of the colour seepage. This process must be done while the original colour is still wet

The Jigsaw Method

To retain immediacy in the medium, it is essential to use the direct approach for the entire painting and not just in isolated areas. The concept of the jigsaw method is to build a complete image. This is done by laying in separate, directly painted, precise shapes of colour – similar to patchwork or the pieces in a jigsaw puzzle – fitting together the various parts in whichever order you prefer, while at the same time continuing to see the full picture.

The jigsaw method in practice

Here I have used a painting of a power saw to demonstrate the jigsaw method process. Mechanical objects can be worthwhile subjects for both painting and drawing, since they contain moving parts; one useful way of evaluating a finished painting is to consider whether the object depicted would appear to work, or not. Since the subject was mostly grey metal with a blue handle, I used a complementary colour palette consisting of Ultramarine Blue and three related orange/browns, Burnt Umber, Sepia and Cadmium Orange, from which I could make a range of luminous greys.

1 I began by making a preparatory drawing in 4B pencil, outlining the various parts of the object and placing in the shadow shapes to fix the object in space. I began the painting with an area of dark grey shadow under the blade cover, mixed from Sepia and Ultramarine Blue with the addition of very little water. I then painted the saw blade, adding more blue to a more diluted version of my original colour, and blending in more Sepia as I worked across the form. I left a small area of white paper to indicate where the light caught the blade.

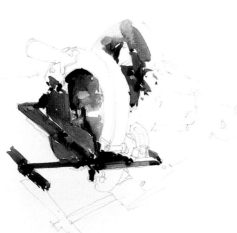

2 I continued with the darker blade cover and frame, using a combination of my original colours with slightly less water and the addition of a warmer grey, mixed from Ultramarine and Burnt Umber, to provide some colour variation. For the darker projecting saw guide, I used very little water in the colour mix. Notice how the edges of the various forms have fused together. I also began to place in the blue handle with Ultramarine Blue greyed with just a touch of Sepia.

3 I carefully painted in the ground shadow working from left to right, beginning with the shape of the saw guide. I blended some Cadmium Orange into the blue/grey mix to warm it a little, and softened the front edge with clean water. I also added in a suggestion of the background as a foil to set off the highlight on the top of the blade cover.

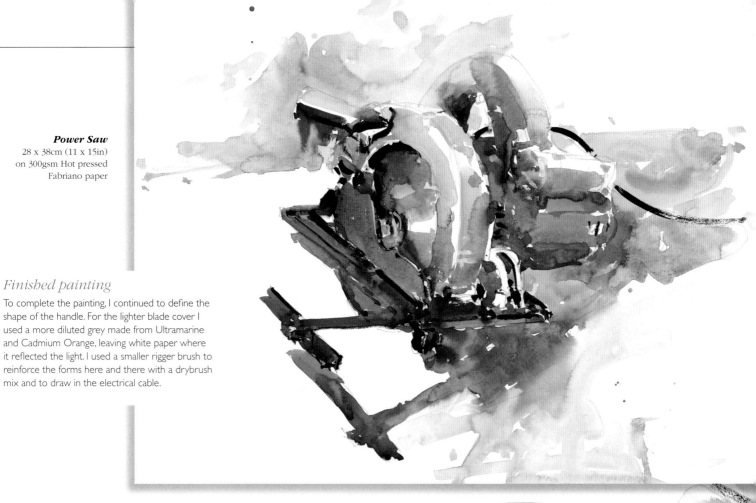

Power Saw
28 x 38cm (11 x 15in)
on 300gsm Hot pressed
Fabriano paper

Finished painting

To complete the painting, I continued to define the shape of the handle. For the lighter blade cover I used a more diluted grey made from Ultramarine and Cadmium Orange, leaving white paper where it reflected the light. I used a smaller rigger brush to reinforce the forms here and there with a drybrush mix and to draw in the electrical cable.

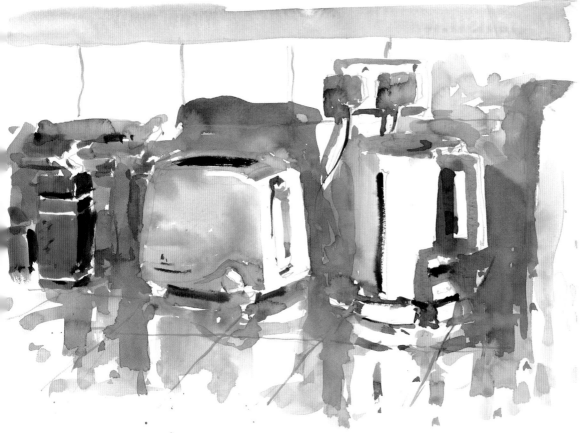

Kitchen Worktop
28 x 38cm (11 x 15in) on 300gsm Hot pressed Fabriano paper
I used the same techniques here, restricting my colours to Burnt Umber and Neutral Tint and using just enough water so that my colours fused at their edges. I overpainted some of the background shadows and foreground reflections to darken them off and crisp up one or two edges here and there, while keeping the painting fluid and understated

Loosening Up

The aim of the loose approach is to let the immediacy and spontaneity of the medium come through to produce lively images. It refers to the way of depicting subjects in an understated manner, in which elements are simply suggested, rather than portrayed with meticulous detail.

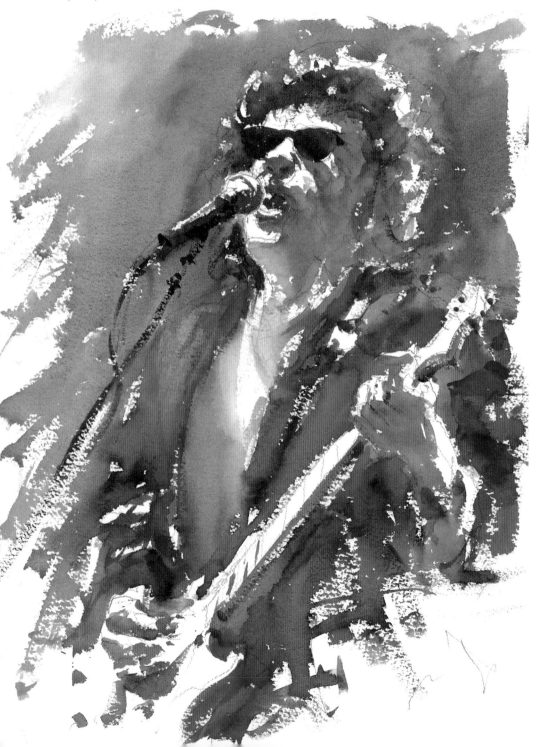

Mark-making

How you apply the medium is crucial to the creation of a loose, understated look and the key factor is simplification. Vitality can be increased when subjects are reduced to their essentials and depicted with descriptive brushwork. Painting loosely does not in any way imply vagueness, sloppiness or inaccuracy, since it requires considerable control to be able to lay in precise areas of colour in one go. The aim is to suggest, rather than overexplain, because the spontaneity of a few well-placed brushstrokes has the capacity to say far more than a fully detailed description.

Rock Singer
40 x 30cm (16 x 12in) on 640gsm Rough surface Arches paper
This is an example of a loose painting in which I wanted the face of the figure to be the centre of interest. I played down the other elements by just hinting at their forms, depicting the hands and guitar with lost and found edges and running together the jacket and background colours to further soften the forms

loosening up in practice

To illustrate the mechanics of the process, I have produced two images of the same subject, the first as a straightforward representation, and the second as a looser interpretation.

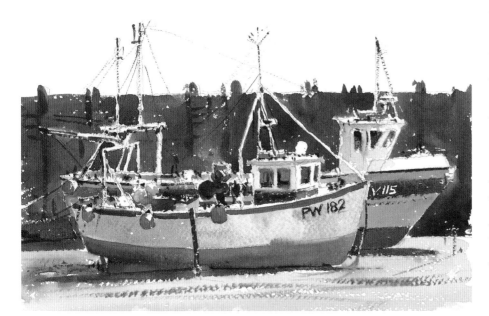

Fishing Boats, Cornwall, no.1 25 x 33cm (10 x 13in) on 300gsm Not surface Fabriano paper
Often the requirement to paint subjects that are technically correct can prevent you giving the medium the freedom it needs to create a looser interpretation, as in the example here

Straightforward representation

Here my intention was to produce an authentic representation of the subject by ensuring that all elements were depicted correctly and in the right places. I gave no consideration to which parts of the subject might be more or less important than others; I simply painted what was there. I accurately drew out the subject in pencil and laid in my colours with directness. I began with the nearest boat, using no.6 and no.8 watercolour brushes, together with a rigger for the fine details. Any thoughts I had about brushwork were qualified by my need to ensure that all elements were to be located in the correct places. The lines of the masts and gantries are white paper, which I formed by painting the shapes of the darker background harbour wall around them. Although this image is a perfectly good representation of what was there, the painted surface marks lack variety and interest. My desire for accuracy led me to exercise too much control over the medium, so much of its potential appeal has been lost.

Looser interpretation

In this image, my principle aim was to generate more energy by using the medium less restrictively. I began with an equivalent drawing to the first example, again matching my colours to those of the subject and laying them in with precision. However, this time I further simplified my approach. Now observing the subject simply as a group of shapes, rather than as specific things, I applied the medium just by making marks, suggesting and hinting at the various elements rather than trying to depict each of the parts in isolation. The paper was the same size as for the first example, but I used a larger no.12 watercolour brush for most of the work so I would be less inclined to be hindered by detail – although I again used the rigger for the finer lines of the masts and ropes. This approach gave a looser, more indistinct appearance. What may be lost in accuracy is more than made up for in added vitality.

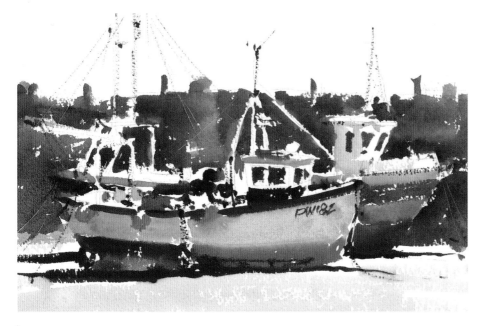

Fishing Boats, Cornwall, no.2 25 x 33cm (10 x 13in) on 640gsm Not surface Arches paper
To paint looser images, reduce your subjects to their absolute essentials, work with the biggest brush that you can, hint at the forms and let your colours fuse so that shapes run together. Notice how I have reduced both sets of mast assemblies to a single shape, which, compared to the first example, simplifies the image and generates sparkle

Creating Informal Reality

The key to creating informal reality lies in providing a direct and simplified version of your subject, which, when combined with the freedom of a loose approach, enables things to remain understated. It requires precise judgment in applying the medium, making certain that each application of paint places elements in the right colour and, more importantly, at the correct relative lightness or darkness.

Painting impressions

Informal reality is about producing impressions of your subjects rather than photographic likenesses. Although you still paint what you see, it will be a more direct and simplified version. The most effective way of doing this is by reducing the subject forms to just the essentials, combined with using the medium economically. Think through every brushstroke, never using two where one will do. In the painting right, activity was concentrated on the area of the shop fronts and figures, so I drew attention to this with strong, understated light-to-dark and colour contrasts.
To balance these busier areas, I left the rest of the painting fairly empty. Incorporating areas of activity and more passive, restful areas in paintings leaves something to the viewers' imagination and has the effect of allowing a painting to breathe.

Street Scene
33 x 26cm (13 x 10in) on 640gsm
Not surface Arches paper
Understating the forms creates a more relaxed interpretation of a subject. In this painting I also used light against dark contrasts – identified as (A) on the image – to draw attention to the active areas, namely the figures and projecting canopies. Much of the rest of the painting I left more or less to the viewers' imagination

Being decisive

A common problem is trying to include too much in a painting, so you must learn to be selective. Deciding what you are going to include and – probably more importantly – what you are going to leave out are fundamental issues to be resolved at the outset. Here again, the solution is to simplify; the maxim 'if in doubt leave it out' is always worth keeping in mind. Combinations of indecision and uncertainty are frequently the underlying causes of images lacking clarity. It is always preferable to focus in on the particular rather than painting generalizations. In the painting right, I chose as my subject a small part from a larger figure group, because the interrelationship between the figures appeared to separate them from the rest. I first produced an outline sketch and then began by painting the two sunshades with decisive brush marks. I laid in a more passive simplification of the background forms, painting away from the hard-edged shapes of the sunshades and blending one colour into another, while cutting around the shapes of the figures, sunshade pole and tabletops. Finally, I placed in the figures themselves, keeping their forms understated.

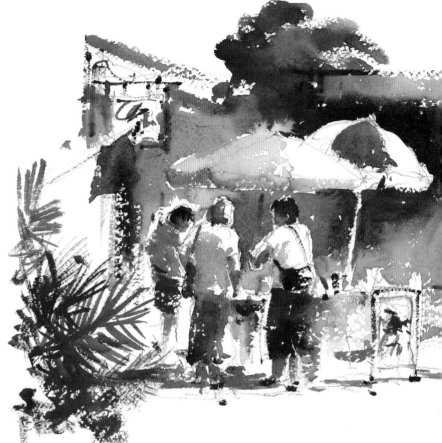

Conversation

26 x 23cm (10 x 9in) on 300gsm Not surface Fabriano paper
Think about where you want the viewers' attention to be directed before you begin a painting; it will then be easier to decide which parts of your subject are less important. Here, in contrast to the previous image, the active foreground elements are set against a much darker, passive background, which I reduced in intensity by blending the colours together

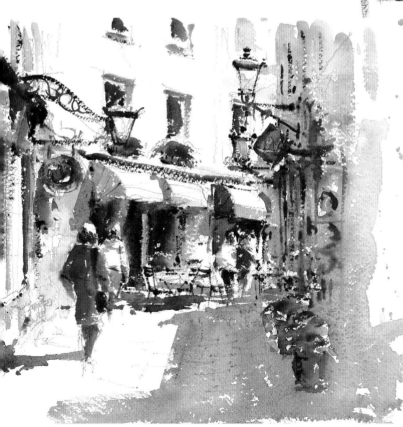

Varying the marks

Although the direct approach is ideally about getting things right first time, in reality it is inevitable that some degree of overpainting will be necessary to pull together, or further describe, some of the forms in a painting. However, you should get away from the safety of gradually building up the darks by overlayering separate washes of colour. The direct approach requires us to be more adventurous, often putting in some darks right at the start, or working out from one particular point in an image. In the painting left, I began by painting in the shapes of the dark shadowed areas under the shop canopies, cutting around the shapes of the figures, which at this stage I left as white paper. As the painting progressed, I needed to pull together the darker, shaded right-hand wall and ground shadow, which I laid in as a single wash of broken colour. I used semi-drybrush marks to depict the lines of the right- and left-hand windows and streetlights, to provide variety. These variations of understated surface marks add to the sense of informality.

Quiet Street

28 x 28cm (11 x 11in) on 300gsm Fabriano Not surface paper
Although I have understated all the forms, I have kept the painting alive by incorporating a variety of surface marks, including drawing with the brush. I have also left some areas inactive, to increase the prominence of the focal features

Ways of Seeing

Central to the direct method of painting is looking or, more precisely, observing things in the world around us in a particular way. This is often referred to as seeing with an artist's eye. This is the starting point for successful paintings, because the way in which we perceive our subjects will have a considerable influence on how we come to interpret them.

Abstract seeing

If you wish to draw and paint well, it is vitally important to observe your subjects, whatever they may be, in parallel ways. You should see them as a concrete 'thing' or 'group of things'. More importantly, you should try to see them in an abstract way too, so that those things that make up the subject are seen reduced to a simplified pattern of interlocking shapes that fit together to make up the whole. This is a subtle, yet necessary, shift in perception, which enables the drawing and painting process to be tackled in a less subjective manner. Rather than painting subjects as things, you will be painting the relationships between the things within your field of view. This requires a less analytical approach, making it easier to paint only what you *see* and not what you *know* about a subject, which is often why people experience difficulties. If you are too analytical, your paintings will be more inclined towards technical representations in which authenticity and detail become the main consideration, with a resultant loss of freedom.

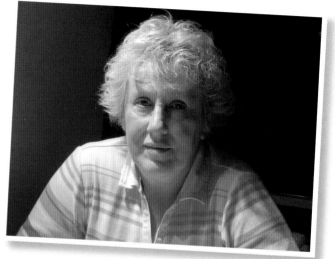

Seeing faces as abstract

When we look at a face, we automatically respond to the features, with the eyes and mouth being the most expressive. However, to draw faces we must alter our perception to see them simply as a range of abstract shapes.

Letting the subject go

To see your subjects in an abstract way, you need to let them go; that is, separate in your mind what the objects actually are from what they look like and how you perceive them. Do not allow yourself to become distracted from this way of looking. I am using a portrait here to illustrate this process, because it is very hard to see faces in this way. Our brains are programmed to recognize the smallest differences in facial details (this is how we tell each other apart), so we naturally respond subjectively each time we look at a face, as we try to decipher subtle changes in facial expressions. If you turn the photograph of the woman's face shown above right upside down, recognition becomes almost impossible. This makes it easier to see the face as just a range of shapes.

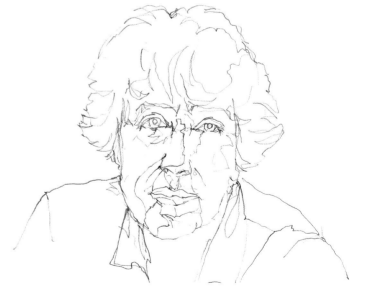

Translating into linear shapes

Here, I have translated the subject into a pattern of linear shapes by placing in the boundaries of all the main forms, including the shadows, without any consideration of which areas might ultimately be more important than others. Where the edges of forms were diffused, I had to make an objective judgment in defining their boundaries.

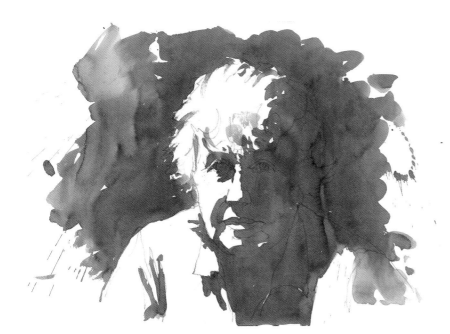

Shaping with light and shade

This time I was looking at the subject to find the abstract shapes created by the light and shade, which I have shown reduced to two values. I painted the shaded areas as a single flat wash of Lamp Black. Here the features have been described only by the shapes of the shadows around them. Even in this oversimplified version, the marks are easily identifiable as a face.

Translating into colour

In this completed painting, I restricted my colours to just Burnt Sienna and Ultramarine Blue. I continued to take an objective approach to the subject, but I also refined it by describing other relevant supporting forms within the original shapes. Again, it is essential to continue looking objectively for the separate shapes that describe the relationships between the forms. This less analytical approach still enables us to see the more expressive features, but now in relation to the spaces around and between them.

Diana
30 x 42cm (12 x 16½in) on
225gsm Bristol Board

Accentuating the Negative

The term 'negative space' refers to those areas between and around the 'positive' shapes of the main elements of the subject. The advantage of painting negative space is simplicity, since the two activities – painting both the object and the shapes around it – can be accomplished in a single application. This helps to make a painting appear less laboured.

Inside and outside shapes

If the positive shapes of a subject were thought of as 'inside' shapes, then negative spaces could be seen as 'outside' shapes. Painting negatively simply means describing an object by painting its 'outside' shapes. Elements suitable for painting negatively will always be lighter than their surroundings, so that they can be contained, or partially contained, by their adjacent forms and described by painting around them. The direct method is ideally suited to this way of working. It is particularly useful for cutting out powerful lights by containing areas of white paper with dramatic darker washes so that the intensity of the contained areas is increased. When painting complex subjects, the decision as to which elements are to be positive or negative will be determined by which parts are lighter than their adjoining areas. The most effective way to do this, whatever the subject, is to try to see the whole image first reduced to a range of simplified linear patterns.

Negative painting

I am using images of *Boats at Sorrento* to illustrate this process, since they were mostly white and therefore naturally lent themselves to being painted negatively.

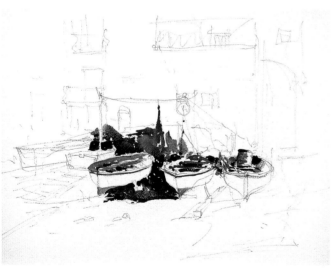

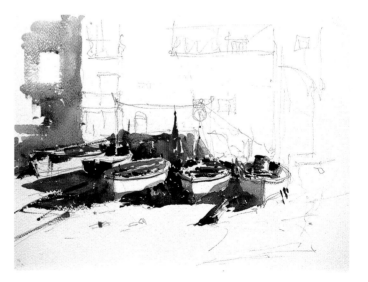

1 Starting with the right-hand boat, I located the shapes of the elements inside the boat hulls with precise, direct applications of paint. I then began laying in the darker shadow and adjacent background forms, cutting around the lighter shapes of the boats.

2 I worked around the shapes of the two additional boats as I continued to feed the dark shadow across the image. I also placed in the lighter-shaded sides of the three main boats and began to indicate some of the background buildings.

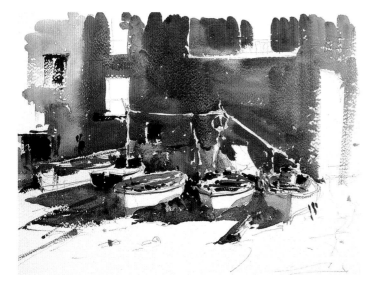

3 As I painted across the buildings, I carefully left narrow lines of white paper to depict the timber framework used for drying fishing nets. The hit-and-miss appearance adds life to the painting.

Finished painting

To complete the painting, I placed in the dark window shapes and foreground shadow, adding a few drybrush refinements but keeping the image understated.

Boats at Sorrento
26 x 36cm (10 x 14in) on
300gsm Rough surface
Fabriano paper

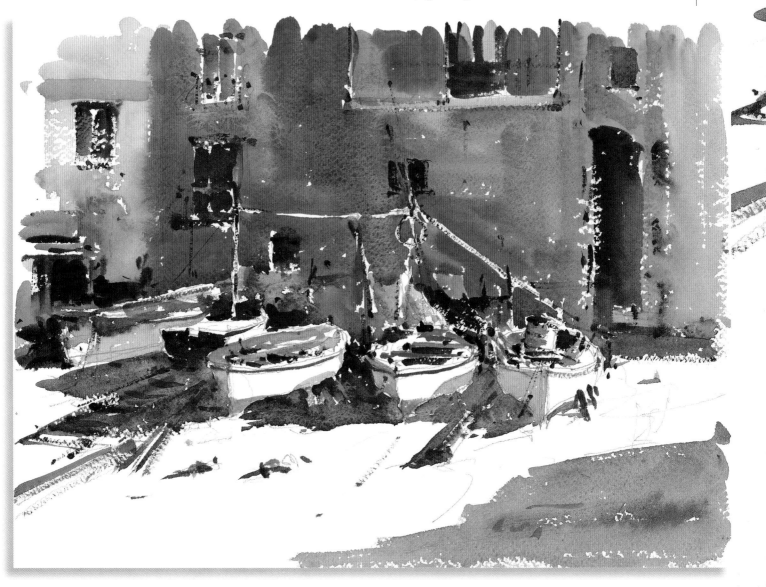

Grabbing the Moment

How we respond to our subjects will have considerable influence on how we might interpret them. Successful watercolours should have the appearance of having caught an instant in time, suspending that particular moment before it changes or disappears completely. Clarity of vision is therefore essential. The most productive way to achieve this is to be certain about the 'what', 'why' and 'how' for each painting before you begin. 'What' is to be your subject? 'Why' did you respond to it in the way you did? And 'how' do you intend to interpret it?

What?

Decisions about subject can seem so obvious that they are often overlooked. With more complex subjects, it is easy to lose sight of your original intentions as a painting proceeds and your concentration perhaps becomes more focused on how you are applying the medium. Be certain, therefore, about what you intend to be the key element or feature of your painting before you start.

Why?

Being clear about exactly why (in artistic terms) you responded to your chosen subject in the way you did enables you to further clarify your visual intentions. This might be, for example, the juxtaposition of contrasting forms, the interplay of light with the accompanying arrangements of shadows, or simply the pattern of shapes in and around the elements of the subject itself. Try not to be distracted by sentimentalized feelings for your subject; this will prevent you from producing an objective interpretation.

How?

The final point to consider, in practical terms, is how to translate your intentions into a painting. You might have to ask questions such as: what is the most suitable size and format for the image? Is it best suited to a sketchy, or more complete, interpretation, either painted 'on the spot', or away from the subject? Would the subject be suited to a limited or an extended colour palette? Or would the mood or essence of the subject be best captured using a chromatic palette?

When you are clear about these three key issues, you will be able to begin a painting with greater certainty, and other decisions will follow on more readily as you proceed. When clear about your aims, it is easier to produce a direct, straightforward and unambiguous statement.

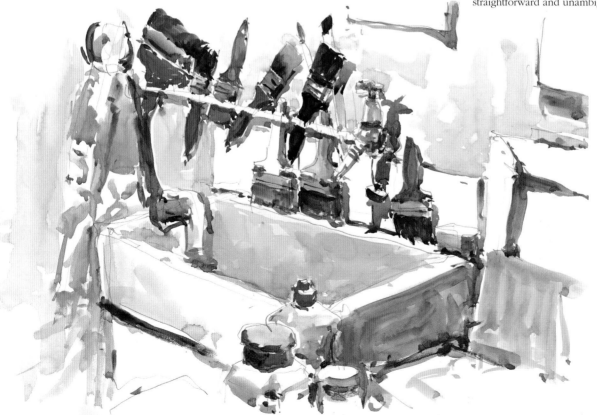

Studio Sink
30 x 42cm (12 x 16½in) on 220gsm cartridge paper
When painting ordinary, everyday things, look for their most visually dynamic features. Here what attracted me was the dominant line of the horizontal water pipe, which cut through the random arrangement of brushes along the wall. I felt I could best convey this with strong contrasts and by emphasizing the distinctive colours of the brushes, while also playing down the surrounding elements

Get up and go

I have to admit that if I were to wait around for inspiration, I would probably never paint anything at all. Developing 'get up and go' is therefore an essential motivational tool that we all need in order to be able to continue and progress effectively. This means making sure you are in such a frame of mind that you are ready and able to respond to potential subject matter whenever you find it. It is advantageous to get into the habit of painting regularly, because this will help you to retain enthusiasm, as well as opening your eyes to the full potential of any subject

matter that you may not have previously considered. Another step that will help you to sustain motivation is, whenever you stop painting – whether this is for a short break or at the end of the day – to always know what you intend to do next. This will ensure that when you begin again, you can immediately continue from where you left off without having to stop and think about it. Even when you are not feeling entirely motivated about painting, this will help you to keep going.

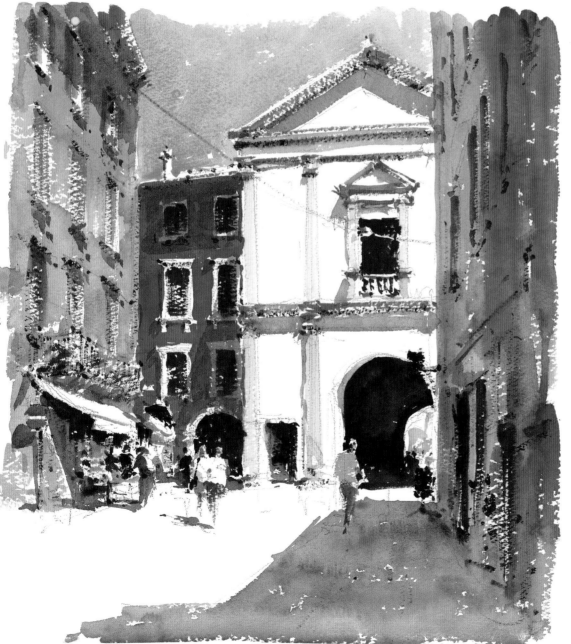

Casa Bianca
36 x 32cm (14 x 12½in) on 640gsm
Rough surface Arches paper
What caught my eye here was how the sun appeared to light up the white building, creating powerful contrasts; my subject was the effect of the light itself. I had to be careful not to overdetail the remaining building façades and the busier shop front, because this would have taken attention away from the focal feature

Chapter 3

Effective Drawing

Drawing is a fundamental, yet frequently overlooked, part of the painting process and the foundation to painting improvement. It is the visual language through which we translate elements from the three-dimensional world on to a two-dimensional surface and therefore a key element in the creative triad. Through drawing, we help to develop the essential eye, hand and brain coordination that is necessary to express ourselves more effectively.

Santa Maria della Salute
29 x 40cm (11½ x 16in) felt-tip pen and
pencil sketchbook drawing

The Investigative Approach

There are three principle reasons why we draw: first, for its own sake, when drawings are produced as ends in themselves; second, to gather information for possible use in future paintings; and third, as a means of investigation or enquiry, undertaken essentially as a personal learning process.

The drawing process

Drawing is the way in which we determine the essentials of a subject, by sifting and selecting from the jumble of visual information before us. In order to progress beyond the basics, it is important to adopt an objective approach with a clear idea of exactly what you want to achieve before you begin. This becomes easier the more you draw, since the act of drawing itself will help to refine your observational skills and thus your ability to select potential subject matter. The process of drawing begins with looking, but there is also a need to see in a less analytical, more abstract way – rather like looking at a road map of a city and seeing just patterns and shapes. The more you draw, the more you will develop these skills in non-analytical observation.

Look for the abstract qualities in your subjects: shape, form, space, texture and contrast, and make accuracy your first priority. Work in an A4- or A3-sized sketchbook and begin by making line drawings using pencil, concentrating only on the edges of forms. Draw lightly to begin with and try not to use an eraser; simply redraw any corrections a little heavier over the top. As you become more confident, you could move on to using felt-tip pens or dip pens with India ink. Since you will be unable to rub out, begin by marking out the general positions of the main elements with touches, or dots, before you commit yourself. Even incorrectly placed marks will become lost as the drawing progresses. Making several studies of your chosen subject will enable you to build additional confidence.

Small Boats
29 x 40cm (11½ x 16in) pen and pencil sketchbook drawing
When drawing the foreshortened curved shapes of boats, visualize your subjects reduced to a series of simplified shapes before you start. This will facilitate seeing both the forms themselves and the equally important spaces between and around them

When and where to draw

The best way to improve is to adopt the habit of drawing regularly: ten minutes each day is preferable to a single two-hour session every two weeks. Combine five- or ten-minute sketches with more detailed studies. The act of drawing will become more like second nature and you will begin to feel more relaxed. Draw whatever happens to be in front of you, whenever the opportunity presents itself, and aim for quantity. This might be at home, during a break in the workplace, or while waiting for public transport – the opportunities are endless. This form of drawing is comparable to an athlete training to maintain his or her performance. You should do it to refine and improve your visual awareness. Looking at drawings in a mirror will immediately highlight any discrepancies that may have previously gone unnoticed. Making several studies of your chosen subject will help you to see it reduced to its essentials. Even when not drawing, get into the habit of looking at your surroundings as if you were; you will be surprised by the variety of additional things you begin to notice within your own environment.

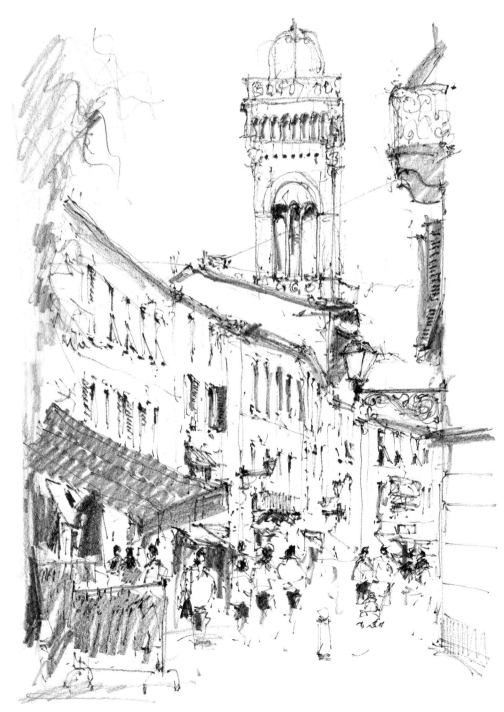

Street in Sestri Levante
40 x 29cm (16 x 11½in) felt-tip pen and pencil sketchbook drawing
When drawing in pen, let the nib just touch the paper to begin with. Darker, more precise, lines can then be added as the drawing proceeds. Including a few supporting figures in street scenes will help to convey life and movement

The Vitality of line

Drawings made in line only – commonly called profile drawings – can display a sense of vitality and individuality that is hard to achieve in any other way. They have a telltale linear appearance that adds energy and freedom of expression. They are an effective way of sketching and for laying out the elementary structure of a painting.

The process

Compared to making measured drawings, the process of profile drawing requires a freer, more intuitive, approach. The general procedure consists of three separate steps: observation, visualization, and drawing. It involves making an outline, or profile, as if tracing around the edges of the subject forms. The photograph right demonstrates the process.

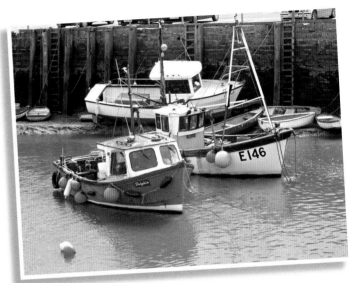

Fishing boats: photograph

Observation

Before starting to draw, it is essential to take a short time to study the outline of the subject forms first of all, to fix them in your mind. In this example, the outline is the boundary shape formed by the outer edges of the three overlapping main boats when seen as a whole. This abstract form can be defined in two ways: by the individual shapes of the boats themselves (the positive, or inside shapes), and by the shapes of the spaces surrounding them (the negative, or outside shapes).

Visualization

The next step is to take a moment or two to visualize this initial shape on your drawing paper, to define the perimeter of the proposed image. I often find it useful to make a tentative outline of this initial shape, holding my pen a couple of centimeters above the paper and drawing it in the air, to establish its size and general intended placement. Neither of these first steps should be skipped over, or rushed, since they are essential stages in the overall process.

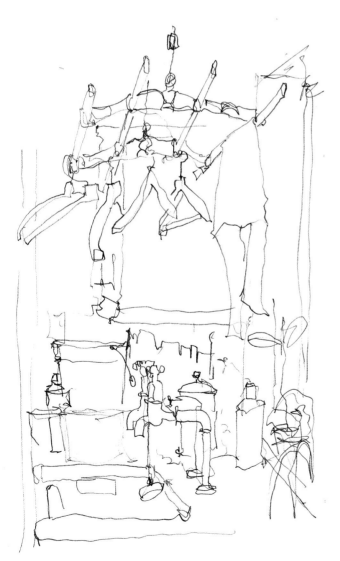

Cottage Kitchen
29 x 20cm (11½ x 20in) 2B pencil sketchbook study
Here I used the profile drawing method to sketch the variety of shapes in this interior

Drawing

The actual drawing can begin from any convenient point on the subject.

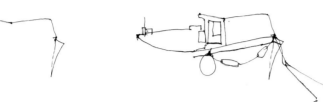

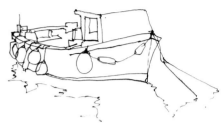

1 I placed my pen at the topmost point of the prow of the nearest boat as a starting point. Looking at the same spot on the subject, I let my eye begin to move slowly down the prow and around the small triangular shape that formed the front, partly hidden, side of the hull and up over the shape of the cabin. At the same time and at the same speed as my eye moved, I allowed the point of my pen to follow, tracing these shapes on my drawing paper.

2 I continued to define the upper lines of the hull and began placing in the general items of paraphernalia at the bows. It is essential to coordinate the movement of your eye and pen, drawing slowly and decisively in a continuous line without lifting your pen from the paper.

3 I continued drawing in the same way until the main forms of the first boat were almost complete. As you proceed, be sure to keep your eyes constantly on the subject, only checking back to your drawing intermittently. It is also most important *not* to try to judge the accuracy, or otherwise, of what you are doing while you are drawing; you will do this at a later stage.

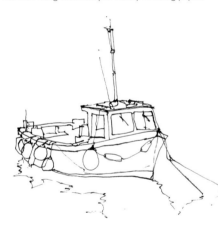

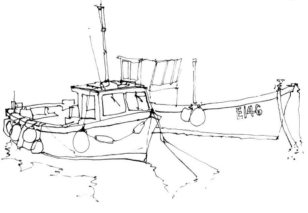

5 I then began to place in the shapes of the other boats in turn, while continuing to see these elements as simplified patterns of positive and negative shapes. The order in which you place elements in a drawing doesn't really matter; so background and foreground forms can be put in together.

4 The foreground boat is now complete. Since this process requires absolute concentration, you may wish to stop from time to time. When you do, simply look away, while leaving your drawing hand where it is, with your pen resting on the paper where you stopped. Then resume working in the same way from where you left off, until the image is completed.

Finished drawing

Only when finished should you analyze the results, and make any necessary adjustments, by comparing what you have drawn with your subject. Do persevere if at first this feels an unnatural way of working, because this method of drawing is a route towards finding greater personal expression.

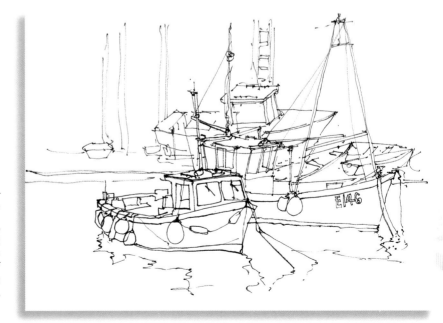

Life Drawing

Figure drawing is a disciplined and difficult activity, requiring a combination of critical observation and precise drawing. It forces us to confront our observational uncertainties. Unlike drawing landscape subjects, for example, where elements can be modified and adjusted and will still appear life-like, even slight discrepancies in the figure will be immediately obvious.

Posture

When drawing the figure, always observe it as a whole and do not let yourself get distracted into seeing it as a group of separate parts, as a head, torso, arms and legs. The most effective way to determine figure proportion is to use the head as a datum, from which to measure and pinpoint other points of reference across the remainder of the body. This can be used whether the figure is standing, sitting, or in a reclining position and even when the head itself is at an angle.

The skeleton enables the body to bend and twist into a variety of positions, so it is important that the angle of posture is fixed at the outset, by drawing in the curve of the centre line of the torso. From the front, this is the line beginning under the chin and extending to the crotch; from the back, it is the curve of the spine. Although most of the skeletal form remains hidden below the surface, there are various places where it can be seen, and these provide additional useful reference points for drawing. The bony points that form the tops of the hips at waist level and the tips of the shoulders are two distinct places that are crucial in defining angle and posture. The hip crests always lie at right angles to the centre line of the torso, whatever the position of the figure. By contrast, the shoulders can move around independently, so it is also important to set out their angle, in relation to the centre line of the torso, early on.

Other places where the skeleton meets the surface are at 'hinge' points; that is, places where the body is able to bend – principally at the hips, knees and ankles on the legs, and at the elbow and wrist joints on the arms.

Standing Nude
40 x 26cm (16 x 10in) 4B pencil on cartridge paper
I have indicated the main force lines of the pose on this drawing: the centre line of the head, the gentle curve of the torso, and the relative angles of the hip crests and shoulders. These lines acted as the underlying structure onto which the subtle outer forms were then located

Gesture and movement

Although the preceding features are key to showing figure gesture, the essential difference is that gesture drawings are about what the figure is doing and show movement, rather than how it is put together. Gesture drawings are good practical exercises, particularly as a warm-up at the beginning of a drawing session. They are best done quickly, taking no longer than ten minutes, in which you should aim to capture the figure's underlying action. Notice how the general shape of the figure changes when walking, sitting or reclining, as weight is redistributed around the body. This is a subtle characteristic that helps to make figures appear more life-like and is much easier to see when drawing from the nude. See the drawing right.

Foreshortening

One particularly problematical aspect is the effect of foreshortening, where a limb is either directly in line with, or at an acute angle to, your line of sight. This makes whichever part of the body is nearest to you appear larger in relation to the rest. Draw the shapes of any foreshortened parts exactly as you see them, not as you *know* them to be. For example, hands are usually smaller than the head but when pointing towards you, a hand may appear much larger in comparison. Similarly, feet will appear much bigger, in relation to the remainder of a reclining figure, when they are seen from close up.

Jayne
29 x 20cm (11½ x 8in) 4B pencil drawing on cartridge paper
This was a five-minute profile drawing in which my aim was to get the essence of the figure by concentrating on the outer shape. Drawing against the clock forces you to be more direct and gives your drawings added vitality

Reclining Nude
30 x 32cm (12 x 9in) 4B pencil drawing on cartridge paper
This was a two-minute gesture drawing, so there was very little time to put in anything but the outer forms of the figure. The foreshortened view distorts the relative sizes of the limbs, making the feet appear much larger in proportion to the rest of the body. Accurate observation in these circumstances is essential

Out and About

Outdoor sketching is a valuable way of recording information and ideas for use in future paintings, and the organized use of a sketchbook is one area that separates the amateur from the more serious artist. Unfortunately, the word 'sketch' tends to imply a rough or unfinished piece of work. This might suggest that sketchbooks are themselves disposable items, which belies their true usefulness. Many artists, myself included, consider their sketchbooks to be priceless commodities because they display personal creative thought processes.

Sketchbooks

Sketchbooks come in various shapes and sizes, both hardbacked and ringbound. Their main advantage is that they contain a number of bound-together pages that can be easily carried around and used in a number of different ways. They come in a range of papers, from lightweight to heavyweight cartridge paper, to tinted pastel and watercolour papers, so choose one to suit your needs. I favour using the hardbacked variety, because these facilitate doubling the size of a drawing by working across adjacent pages. I usually work on both sides of the page, placing in a loose sheet of thick cartridge paper between the pages to prevent existing drawings being transferred from the underside of a page while working on the other side. Although pencil is the most common drawing implement, felt-tip pens, ink-dip pens, even a sharpened stick dipped in ink or a biro make suitable drawing tools. When space or weight are at a premium, I restrict my equipment to a sketchbook and a couple of felt-tip pens and pencils, which then easily fit into my pockets. Sketchbooks can also be the place to try out different drawing or painting media and preparatory working drawings for paintings. Your sketchbook is essentially a personal visual diary, so use it regularly.

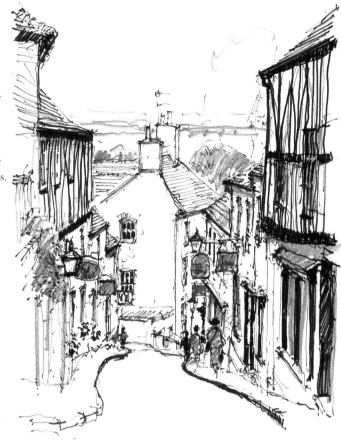

Steep Hill
40 x 29cm (16 x 11½in) felt-tip pen and pencil sketchbook drawing
To create the sense of looking down a hill in this drawing, I had to accurately position all the horizontal lines in the buildings on each side of the street, so that if they were extended, they would meet at the same point on the line of the horizon. The figures help to support this illusion

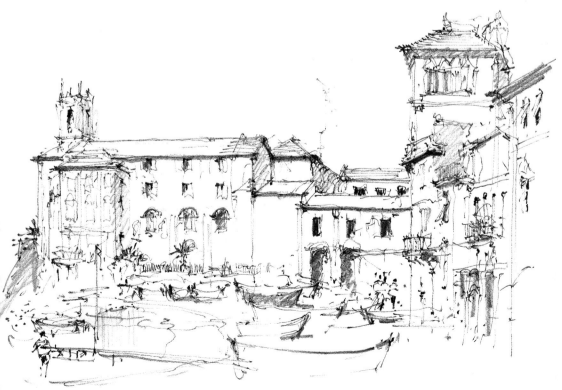

Bay of Silence
29 x 40cm (11½ x 16in) pen and pencil sketchbook drawing
This was one of a series of drawings I made one afternoon in this quiet secluded space. Working across adjacent pages of my sketchbook, my aim was to record the essence of the building forms, which were typically Italian, having shuttered windows, ornate balconies and lines of projecting eaves

Sketching with a purpose

The sketchbook is the place where you collect and analyze information, in the form of drawings in all media, paintings, written notes, or photographs – in fact, any information that you consider worth recording for future reference. Most outdoor sketches will be the result of chance encounters, so the quality of what you produce will, of course, vary from page to page. It will probably consist of drawings or doodles dashed off in a few seconds, through to images that may have taken much longer to produce. The most important factor for all images is that their purpose must be clear, so that when you look at them again in the future they are still understandable. The best way to do this is to make your sketches particular, by focusing on selected elements instead of producing generalized statements. If you find it hard to see things in isolation, cut a 2 x 3cm (1 x 1½in) hole in a piece of card to use as a viewfinder. This, when you look through it, will enable you to see elements of a scene as separate entities, isolated within your general field of view.

Country Station
20 x 29cm (8 x 11½in) felt-tip pen and pencil sketchbook drawing
Sketching can be undertaken whenever the opportunity presents itself. I made this quick sketch in a few minutes while waiting for a train. I had just enough time to lay in the main forms and to suggest the direction of the light

St. Mark's
29 x 40cm (11½ x 16in) felt-tip pen and pencil sketchbook drawing
When drawing buildings with intricate façades, be careful not to become lost in the detail. My aim here was to keep this understated, by simplifying the whole drawing. I added pencil toning to the main shadowed areas to give the building volume, and I included figures to depict both depth and a sense of scale

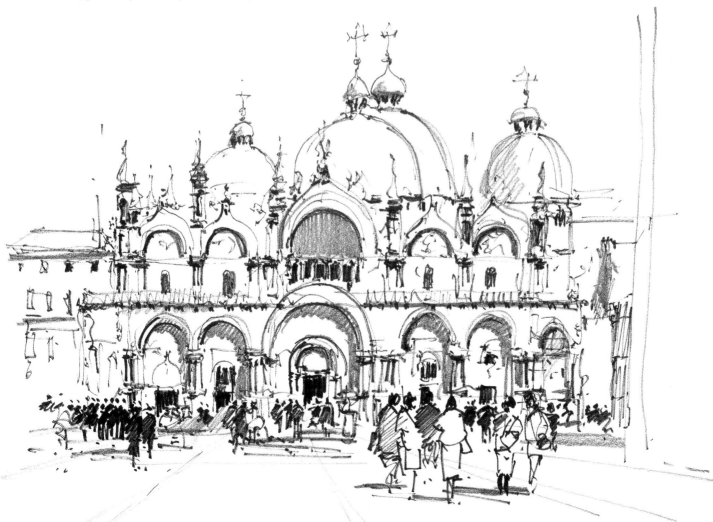

Sketching Figures

Including figures in paintings can add life and movement to what might otherwise be a fairly static image. They do not have to be painted in great detail to look credible, but they should convey a gesture that will give a clue to their purpose. Regular sketching will significantly improve your ability to portray figures more convincingly.

Finding subjects

Although figures are to be seen everywhere, the most suitable subjects to work from will be those that are seated, for example, in cafés, restaurants, parks or on the beach, because they will be more likely to remain fairly still. The most static standing figures will probably only allow you a few minutes maximum to get a drawing down before they change position or move away altogether. When drawing figure groups, it is best to put each figure in separately. At a café table, for example, you may find that in one drawing you have worked from two or even three different subject groups, as one group of people is replaced by another, so you will need to cope with this fluidity. Start by making small line drawings, no more than about 5cm (2in) in size, using pencil, felt-tip pen or even biro, if this is all you have to hand. Concentrate only on the outline shapes to begin with; forget the details in faces, hands and feet. These initial studies should aim to portray the general posture and form of the figure, ideally with the minimum amount of drawing. Work quickly and aim for quantity, getting down the essence of the figure without concerning yourself with the complexities.

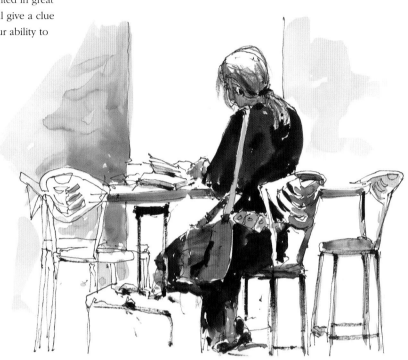

Figure in Station Café
29 x 40cm (11½ x 16in) felt-tip pen and watercolour sketchbook study
I produced this figure study working on my lap with my watercolour pochade box, while sitting at a table in a railway station café. I began by making a profile drawing, and added the colour from memory after my subject moved away.

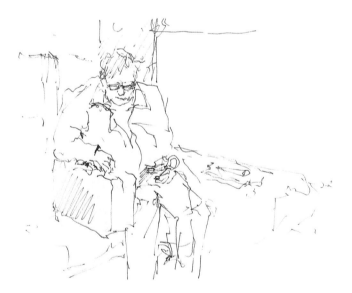

Try not to become discouraged if at first your images appear laboured or unnatural. As with any learning process, making mistakes is a necessary part of the path towards improvement. As you become more proficient, you can move on to making ink or watercolour brush drawings, which again should concentrate on portraying the overall figure shape and gesture.

Man on a Train
20 x 29cm (8 x 11½in) felt-tip pen and pencil sketchbook drawing
When sketching figures, it is better to try to work incognito. This often means, when in close proximity to your subject, snatching just a glance for a few seconds at a time and working from memory. Here, I soon realized that my subject was so engrossed in his book that he was oblivious to me

Moving figures

When drawing figures in motion, you will need to work quickly: you will only have a maximum of about five or six seconds before your chosen subject has passed by. In contrast to a posed model, moving figures possess a purpose, or function, which will be reflected in the gesture of the body movement; the principal aim of any drawing should be to try to capture this underlying characteristic. A challenging test is to look only once at your chosen moving subject for a couple of seconds or so, in order to fix the essential characteristics in your mind, and then, without looking back, draw all that you can remember as quickly as you can. Although this is quite difficult at first, working in this way will further encourage the development of your visual memory. This will also enable you to build up a reference library of figure drawings for use in future paintings.

For an additional challenge, try making rapid drawings of figures on public transport, or brief gestural sketches of figures in the street. Having to work quickly will sharpen your observational skills to the essentials of your subject. Remember, these drawings are being undertaken for your own training, as a developmental process for you as an artist, and not for the benefit of others.

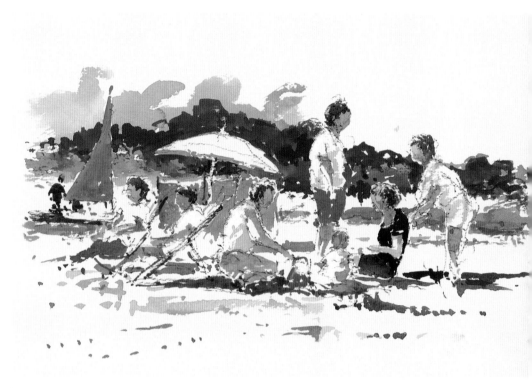

Beach Figures
12 x 18cm (5 x 7in) felt-tip pen and watercolour sketch on 300gsm Not surface cream-tinted Bockingford paper
It is possible to find numerous subjects in crowded places, provided you can remain unnoticed. Here I sat on the ground, with my sketchbook on my lap and using my pochade box. I limited my painting to blocking in areas of local colour and adding back the lights with white Conté

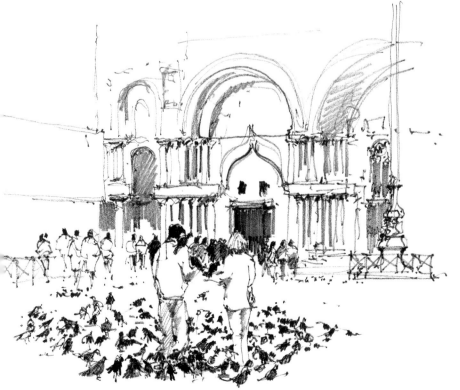

Feeding the Pigeons
29 x 40cm (11½ x 16in) felt-tip pen and pencil sketchbook drawing
Sketching people means having to cope with constantly changing circumstances. Here, there was a group of about five or six people in the original scene, but I had the chance to complete only two before they moved on. I then drew in the building, the distant figures and the pigeons

Drawing for Painting

Producing 'on site' drawings is the traditional way of collecting information for paintings. They can provide a source of inspiration for months or even years after the original drawings were produced.

Information gathering

Drawings made for painting will usually be produced in circumstances that do not allow for a complete study, so to be useful, however brief, they need to be clear and concise. When you come to work from them at a future date you will probably have no remaining visual memory of the actual subject, so it may be useful to include written notes relating to aspects of the subject that would not be obvious from the drawing. This might include weather conditions, sounds, and even smells when drawing industrial subjects, for example. Write down anything that you think might help to rekindle your original response.

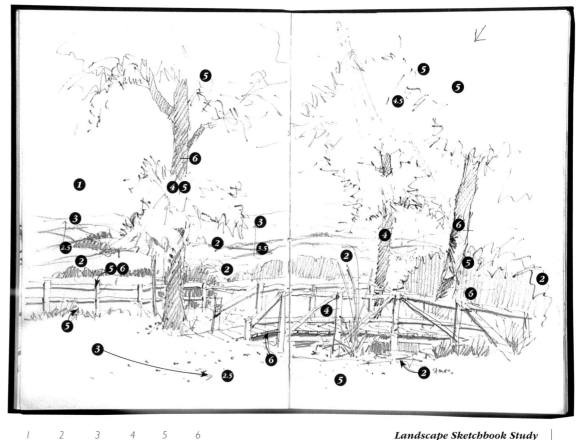

Six-value tone scale against which I recorded the light and shade of my subject

Landscape Sketchbook Study
29 x 40cm (11½ x 16in) pencil sketchbook drawing
A rapid and effective way of recording a subject's light and shade is to identify areas of similar tonal values with numbers that correspond to a predetermined tone scale. You will find it easier to identify the lightest and darkest values first, and then complete the remaining intermediate tones. I identified the lightest lights with no.1, and used no.6 for the areas of darkest darks. Then I made a judgment for the remaining areas of the subject, noting their nearest relative values with the remaining four numbers. These numbers match a six-value tone scale. I worked back from this scale to produce a complete tonal sketch by rematching the numbered values in the original drawing

Recording light and shade

Light and shade, rather than colour, is the preferred characteristic to record. Producing a fully rendered image would be too time-consuming, so it is essential to use a more convenient method. In this landscape sketch, I used number references (1 to 6) to record the pattern of light and shade across the subject.

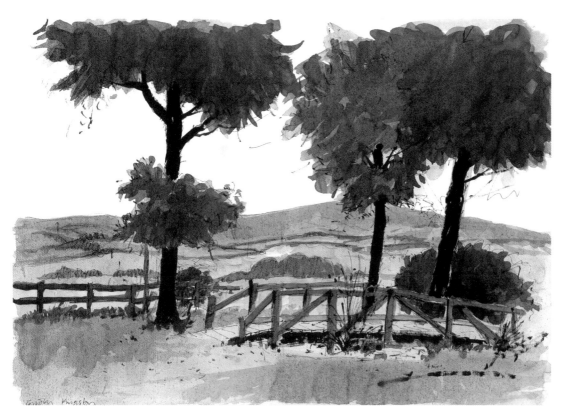

Studio Tonal Sketch
29 x 40cm (11½ x 16in) on plain
paper photocopy
_Here I have transcribed the
light and shade from my
original drawing. The simplest
way of doing this is to paint
on a plain paper photocopy of
your original drawing, as I did
here. This allows you to retain
your original, it saves the time
of redrawing, and, if you make
a mistake, you can simply take
another copy and start again_

Recording colour

When producing studio paintings, we have the opportunity
to use whichever colours we wish. It would therefore be
counterproductive to try to record every colour combination in
your subjects. Be selective and limit any colour notes to specific
areas that you consider relevant for a future painting, either with
written notes or the actual colours, as illustrated in the example
from my sketchbook below right.

Using a camera

Many artists use photographs as a means of recording subject
material in addition to drawing. Although the advantage of
the camera is that it can record a wealth of information in a
short amount of time, this ease of use can also be its greatest
drawback. The processes of drawing and using a camera both
convert images to two-dimensional form, either on paper
or as photographic prints, so when we come to work from
photographs we lose that essential three-dimensional 'real
world' response. The crucial difference is that the camera cannot
discriminate; it simply records every detail of whatever it is
pointed at. The act of drawing, however, is a synthesis: it is a
creative process of sifting and selection, in which we seek to
define our response to a subject as we see it. I recommend that
if you do have to work from photographs, draw from them first,
in the same way you would do if working 'on the spot'. Then put
the photograph away and paint only from your drawing. Unless
you are experienced in working directly from observation, you
will be in danger of simply producing paintings of photographs
of subjects, which by their nature will be flat and lifeless.

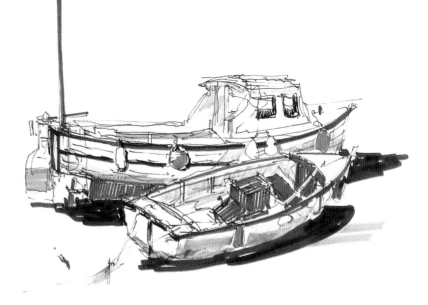

Two Boats
15 x 20cm (6 x 8in) ink and coloured felt-tip pen sketchbook study
_In this sketch I used coloured felt-tip pens to record the local colours of
the lines on the two boats. Accurate and informative drawings are the
most useful reference material for future paintings_

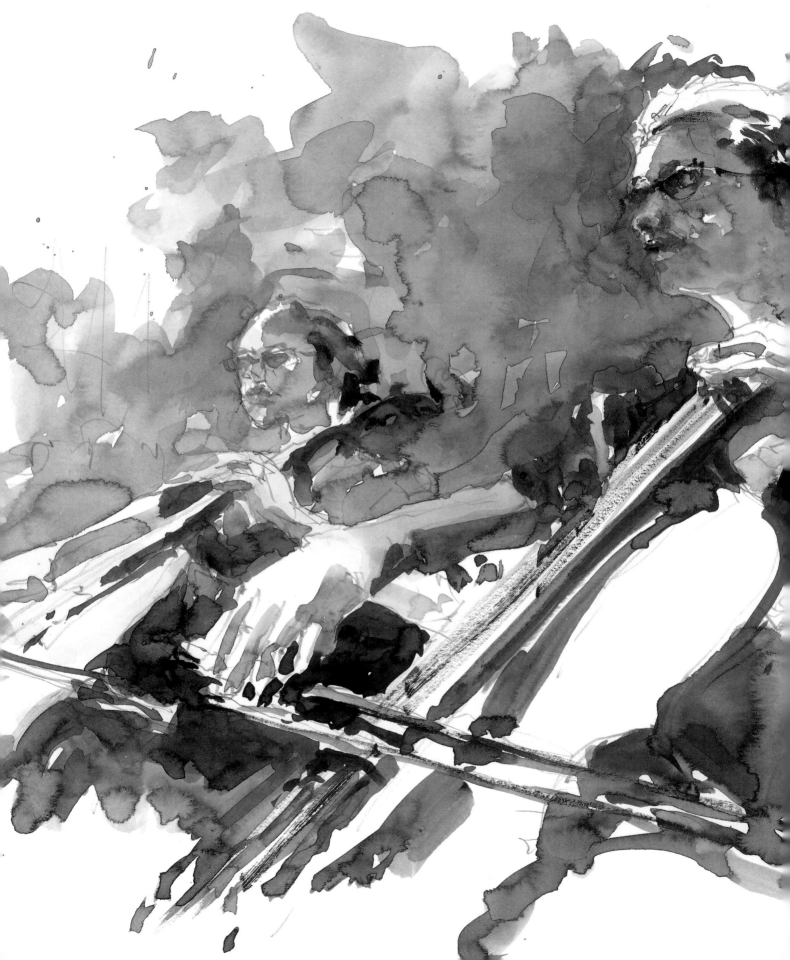

Animating with Tone

Tone (also called value) refers to the relative lightness or darkness of elements compared to a grey scale, irrespective of colour; rather like looking at black and white photographs. It is used to depict light and shade, space, distance and atmosphere, so a well-organized tonal arrangement is the catalyst for bringing images to life. It also forms the essential underlying structure for sound colour application.

Cellists
30 x 42cm (12 x 17in) on 250gsm Bristol Board

Creating Illusions

For paintings to display energy and flair, they have to convey something of the essence or spirit of a subject. This means they need to be more than mere photographic copies, and tone is crucial in creating this illusion.

Judging tones

The human eye is capable of seeing an almost infinite number of tones from white through to black, but when painting we need to simplify this into a more manageable range. A tonal scale consisting of five steps works well in practice; white paper acts as the lightest light and black as the darkest dark, with a range of three equally spaced tones in between. Working with an odd number of tones creates a middle value, which then sits halfway between the lightest light and darkest dark. The two remaining intermediate values then lie halfway between both the lightest and darkest values and the middle value respectively.

When looking at subject matter, it is relatively easy to spot the lightest lights and the darkest darks. However, it is more difficult to judge the remaining in-between values, because as we move our eyes they constantly adjust to any slight variations in the light. Be aware when painting that very often areas that appear to be quite light at first glance are more likely to be closer to an upper middle value on the tone scale.

The most effective way to see tones is by narrowing your eyes or squinting; this will heighten the relationship between the lights and darks. Always look for the tonal extremes first; then, by slightly opening and closing your eyes, you will be able to spot the areas of middle value. The remaining two intermediate tonal areas can then be found by repeating the process. This will always require a degree of judgment, but will become easier with experience. As you become more used to seeing tones, the five-tone scale can be extended to include seven values.

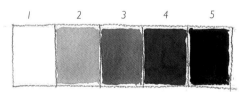

Tonal scale consisting of five values extending from white to black

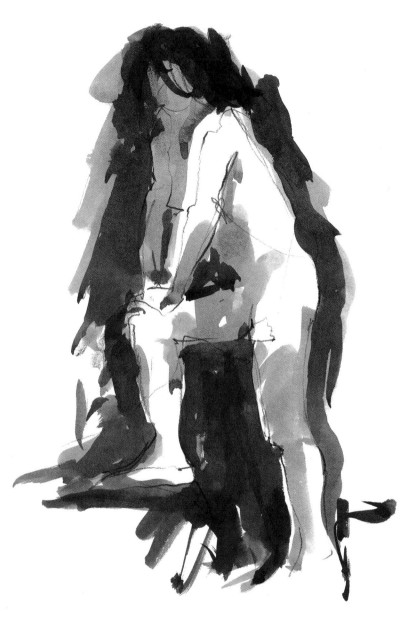

Nude Study
40 x 33cm (16 x 13in) 6B pencil and watercolour on cartridge paper
In this three-minute life sketch, I worked with a reduced range of five values, preserving the white paper for my lightest lights and blocking in the rest. Notice that much of the figure has a tonal value of 2, one step darker than white, but it still appears relatively light, because I have contained it within a darker area of tone

Light and shade

Tone is dependent upon light and, in essence, it is used to depict all the planes on an object except for the part that receives the full intensity of the light. The areas on a form that receive full light will be the lightest; areas that receive only glancing light will be slightly darker; areas that face away from the light and therefore receive no light at all will be darker still, and will also cast a shadow. Shadows are the projected shape of an object as cast on to an adjacent surface and are therefore areas of negative light (places where the light cannot reach). Areas on an object that face away from the light will also receive reflected light, which bounces back from adjacent surfaces. This is critical in describing rounded forms and will be relative to the general lighting direction, as in the painting right. When looking against the light, forms tend to become reduced into silhouetted shapes, as in the painting below. Objects will then tend to become progressively lighter as they recede into the distance.

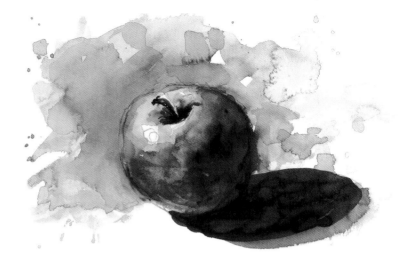

Tonal Study of an Apple
15 x 20cm (6 x 8in) on Hot pressed Fabriano paper
Greater authenticity can be given to rounded forms by including the small area of reflected light where the curve of the shaded form approaches its shadow

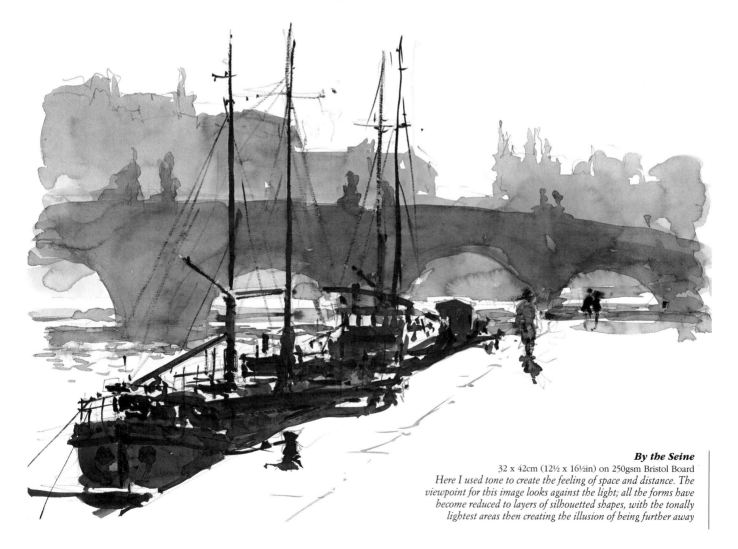

By the Seine
32 x 42cm (12½ x 16½in) on 250gsm Bristol Board
Here I used tone to create the feeling of space and distance. The viewpoint for this image looks against the light; all the forms have become reduced to layers of silhouetted shapes, with the tonally lightest areas then creating the illusion of being further away

In conditions where the lighting is diffused, it will be more difficult to distinguish separate elements, because the general tonal arrangement will be more fragmented. Some manipulation of the tonal relationships may therefore be necessary, to create more dynamic interpretations.

Achieving balance

Paintings need to have a well-defined centre of interest, so your tonal relationships should be adjusted to direct the eye towards this. Where tones are all virtually the same, the centre of interest will be less distinct and paintings can then appear muddled and bland. It is important for images to be balanced, by focusing on the centre of interest within a unified pattern of tonal relationships. To create balance, tones need to be adjusted so that they relate to each other. This means keeping it simple; do not become distracted and place in lots of individual touches of irrelevant detailed values, even though you may see them in the subject. This will only cause confusion and loss of clarity.

Manipulating tones

The photograph below left is an example of confusing tonal values. I took it on a rather overcast day to support an 'on the spot' sketch that I had made earlier. I had initially been attracted to the activity and variety of shapes around the area of the small canopied shop fronts. Although the photograph depicts the quality of the environment, it is dull and uninteresting and does not equate with the visual response I had when I was actually there (which is often the case with photographs). The image lacks clarity because the tonal values are all very much the same, without any highlights or well-defined contrasts. I had wanted to depict the scene as I had initially seen it, bathed in light, with descriptive directional shadows. To do this I needed to modify the tonal relationships.

Sorrento Side Street: photograph
The impact of visually appealing subjects can often become lost in photographs

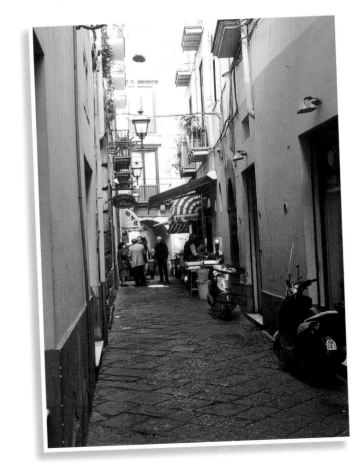

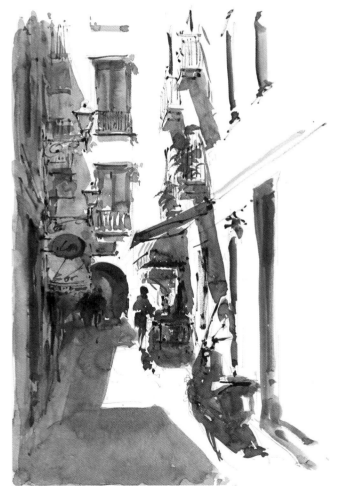

Sorrento Side Street
46 x 30cm (18 x 12in) tonal sketch on cartridge paper
When producing tonal sketches, concentrate on the large masses, defining the focal point first

The sketch shows my revised tonal interpretation, in which I have strengthened and enhanced the centre of interest. I used my strongest tonal contrasts, juxtaposing my lightest lights with some dark values, to draw attention to the shapes and activity around the shop front, my focal point. When producing tonal sketches, it is always a good starting point to locate the tonal parameters first, between which the more subtle intermediate tones can then be adjusted. I continued by laying in the remaining areas in the image as a simplified pattern of intermediate tones. To achieve balance, it is essential not to divide the general lights and darks in equal measure. The breakdown here is approximately one-third darks to two-thirds lights. The lighting direction can also make a painting appear more dynamic.

I chose a lighting angle that would generate descriptive shadow shapes from the projecting canopies onto the sunlit walls. This then meant that the left side of the street would be in complete shade. I initially indicated this with a flat wash of a mid-tone (value no.3), over which I placed darker shapes to suggest the various other features. To retain unity in the painting, I made certain that my tonal changes extended across the full tonal range of values and were not just concentrated at the extremes. In other words, don't simply lighten and darken single elements in isolation. You may need to do several tonal sketches to find a suitable tonal solution. See these as working drawings, produced as an essential stage in the development of a painting, rather than tackling them as finished paintings in themselves.

Outdoor Café: photograph
This is another example of a subject displaying considerable visual interest, but here again the tonal values need simplifying to create more impact

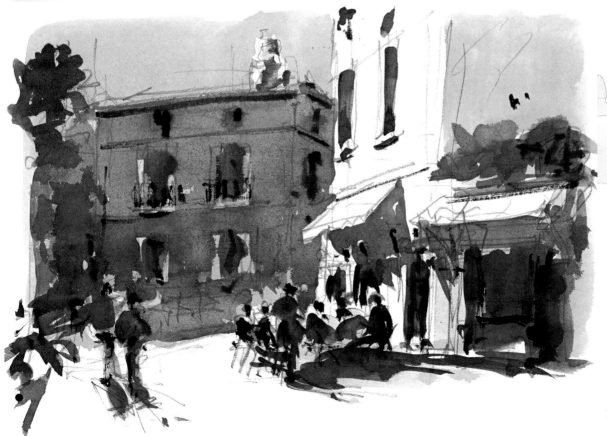

Outdoor Café
30 x 40cm (12 x 16in) tonal sketch on cartridge paper
If an image does not come together tonally, it is far less likely to work in colour

Expression with Edges

The control of edges is a powerful way of generating expression in paintings. The separateness of shapes and forms is described by their edges, which can be used as a convenient means of emphasizing, suppressing or unifying particular areas or features.

Edge definition

The treatment of edges is a crucial factor when determining patterns of light and shade. To the eye, hard edges are more distinct and will therefore appear more dominant, compared to softer, more blurry edges, which will essentially melt away. Aim to structure your edge treatment so that you incorporate hard edges where you wish to direct the viewers' attention, and softer, blended edges for the areas of the painting that are less important. Where all the edges in a painting are defined in the same way, even well-painted images can appear rather stiff and unlife-like. Varying the junctions between the forms with 'lost and found' edges will provide additional life and movement. In the painting below, I used hard edges and strong contrasts to define the sails on the boats. The dominant forms of the poles are also an important feature because they lead the eye back to the figure group, which I have painted more generally, as a single mass, linking their forms together with softer edges to reduce their importance.

Sailing Boats in the Luxembourg Gardens
30 x 40cm (12 x 16in) tonal study on 250gsm Bristol Board
To give your images greater clarity, use your edges to pull the eye towards the centre of interest. Here the boat sails are the dominant forms, so I simplified the rest of the image, painting the figures as a single mass combined with softer, less distinct edges

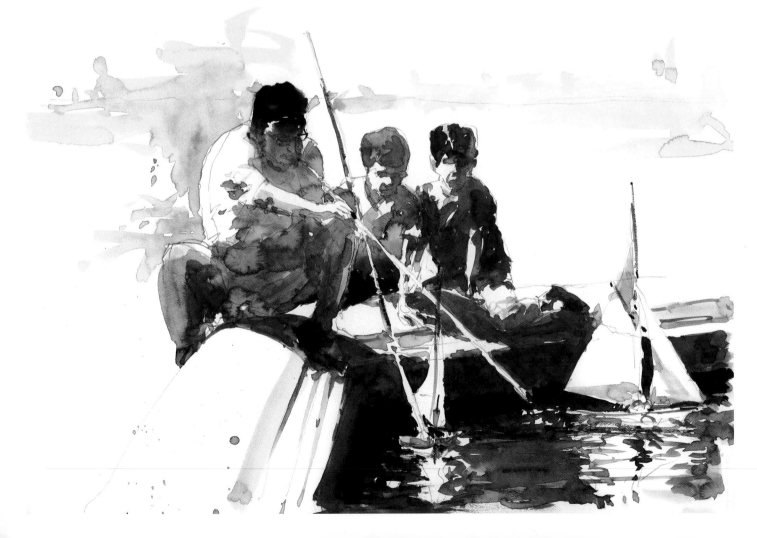

Tonal counterchange

Edge treatment can play a vital role in integrating all the parts of a painting. If you use only hard edges, your subjects will appear rigid and lifeless, whereas edges that are exclusively soft will create only indistinct forms. The solution is to be selective, being guided initially by what you see and then emphasizing selected forms with tonal counterchange. In the painting right, I emphasized the light on the front of the torso and right leg by including a contrasting darker background tone. Since the head was mostly in shade, I did the same thing again, in reverse, although there is a thin descriptive line of light along the front of the face and neck. I also merged the shaded side of the figure into the tone of the background to reduce its dominance. Notice the tonal counterchange across the arm. By letting the tone of the upper arm blend into the background, I was able to add emphasis to the lower limb where it came back into the light. Where the tonal values of adjacent forms appear to be the same, paint them exactly as you see them. These junctions form contact points where the subject and background elements appear to join together. This prevents images appearing as a subject set against a separate background. Similar areas of tonal connections can also occur within the forms of the subject itself, but you will need to look carefully to find them.

Exit pathways

In the same way that a central point of interest is designed to draw in the viewers' attention, we also need to include areas or spaces that enable the eye to move outwards, away from the focal areas. These are essentially areas that are left partially incomplete and might be a single point within a form, or an entire form or group. When these characteristics are combined with well-thought-out tonal arrangements, they add to the expression and fluidity of paintings. In the painting below, the incomplete left foot and right hand allow the eye to run out from the figure forms into the background.

Julia
40 x 28cm (16 x 11in) tonal study on cartridge paper
This five-minute study, produced at the end of a day's life drawing, catches the gesture of the figure with just a few flat areas of tone. Time-constrained studies force you to be decisive, because you only have time to get down the essentials of the subject

Anne
26 x 38cm (10 x 15in) tonal study on cream-tinted Bockingford paper
For this five-minute tonal study, I used Burnt Sienna and Lamp Black in conjunction with a cream-tinted paper. Essentially a study of the light on the curve of the reclining figure, I ran the forms together where they appeared to be tonally the same and left the extremities as visual exit pathways

Seeing Colour as Tone

One of the most confusing characteristics to identify with colour is its relative tonal value. However, we have to be able to recognize this in the colours we see in our subjects and then incorporate it in our paintings.

Inherent colour values

In terms of colour, tone refers to a colour's relative lightness or darkness, as compared to a grey scale, irrespective of the actual colour itself. For example, Cadmium Orange, when squeezed straight from the tube, has a higher tonal value (is lighter) than Cadmium Red or Burnt Umber. On the other hand, Sepia and Indigo are darker, so they are said to be of lower tonal value. To the right I have shown the inherent tonal values of a range of colours matched to a grey scale. In the example, the yellow is lighter than the blue and the red, although different hues from the same colour ranges will also show comparative variations in their inherent tonal values. Recognizing and judging the relative tonal values of colours in your subjects is fundamental in establishing both colour control and an overall tonal structure in your paintings. When looking at any area of colour, the first question always to ask yourself is: how dark or light is it?

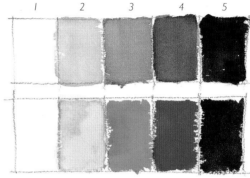

| 1 | 2 | 3 | 4 | 5 |

White paper Raw Sienna Cerulean Blue Cadmium Red Indigo

Colour/Tonal Value Comparisons
This is an example of a random selection of colours whose inherent tonal values match a five-tone grey scale. There are, of course, numerous other comparable colours that would also match the scale

Using colour tonally

It is best to begin by determining an overall range and distribution of tones for a painting, because this will provide a sound structure on which to base your colour applications. Without such a foundation, colour control can often be a more random operation, based on intuition rather than order. Intuition, of course, should not be ignored, since it plays a fundamental role in artistic creativity, but it will be far more effective when based on an organized tonal structure. Provided the tones in a painting are correct, a diverse range of colours might then be chosen to create whichever pictorial representation might be preferred. I have used three paintings to illustrate the process. Each image is tonally correct, but each one creates a quite different impression.

Tonal study

I painted this tonal study first, using Lamp Black, simplifying my general tonal pattern into a range of five values. I lifted my lightest lights to white paper and adjusted the remaining tones on a scale through to black. My aim was to set out the general tonal structure for the image.

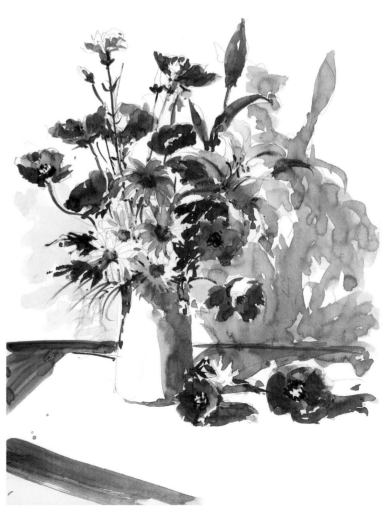

Flower Study 1
40 x 29cm (16 x 11½in) on cartridge paper
When producing tonal studies, establish your centre of interest first. Here it is the group of white daisies, which I made appear lighter by surrounding them with strong darks

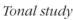

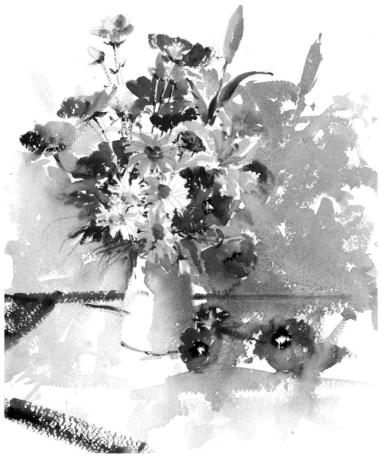

Taking colours from the subject

I selected my colours for this painting from the colours in the subject. I used Cadmium Lemon, Raw Sienna, Cadmium Orange, Cadmium Red, Burnt Sienna, Cobalt Violet, Neutral Tint, Cerulean Blue, Ultramarine Blue, Prussian Blue and Indigo, mixing the colours on the palette and blending them on the paper. I worked as described previously, painting loosely and directly, and matching my colours to the tonal values in the subject.

Flower Study 2
28 x 36cm (11 x 14in) on 300gsm Rough surface Fabriano paper
I based my colour selection for this painting on those that I felt best matched the colours in the subject

Matching colours to the tonal study

For this painting, I used the selection of four colours referred to in the previous colour/value comparison (Raw Sienna, Cerulean Blue, Cadmium Red and Indigo), applying my colours straight from the tube and allowing them to mix only on the paper. My approach was to ignore the actual colours in the subject itself. Instead, I worked from the first tonal image, matching my colours to the corresponding value on the colour/value scale. I used Indigo for the darkest darks. The poppies, which in reality appeared to be three tones of red, I now painted with Raw Sienna for the lighter tones, Cerulean Blue for the middle tones, and Cadmium Red for the darkest areas, based on the corresponding colour/value scale. Because the tonal values are correct, even though my colours are rather 'wild', the image doesn't appear to be incorrect – we simply have a different emotional response to it.

Flower Study 3
28 x 36cm (11 x 14in) on 300gsm Rough surface Fabriano paper
Provided your tonal values are correct (in relationship to each other), different colour groups can be used to give a range of alternative, more personalized, colour effects

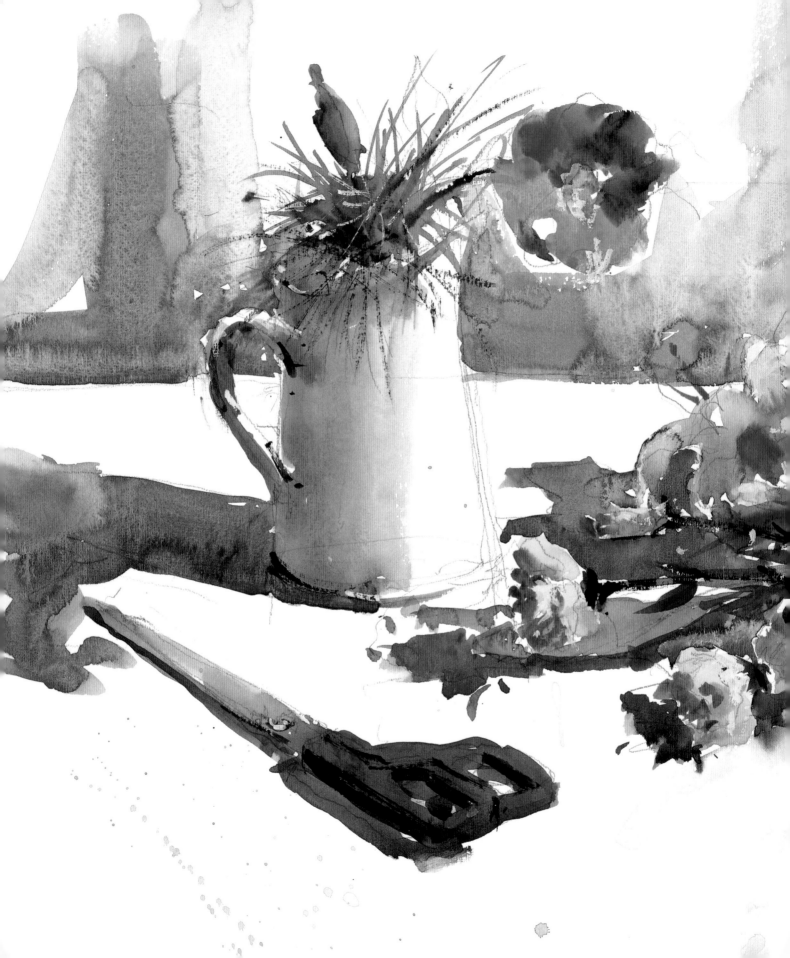

Enlivening with Colour

Colour appeals to the emotions; we therefore react to it with our feelings, which can make it appear somewhat elusive to pin down. Its influence is similar to the effects of harmonies in music, adding greater meaning and expression. But colour also needs to be controlled, set into a prescribed key, or based on a well-orchestrated tonal structure, otherwise it can appear rather insignificant.

Summer Flowers
35 x 50cm (14 x 19½in) on 300gsm Not surface
Fabriano paper

Colour Choice and Effects

Since colour can be used in so many different ways, it cannot be contained within a rigid framework. It is often seen as a rather haphazard process, without specific rules or formulas to ensure guaranteed results. Finding satisfactory colour solutions will always therefore be based, to a large extent, on our own subjective responses.

Colour perception

For painting we need to be able to recognize and control four basic characteristics that together define how we perceive colour: hue, tone, temperature and chroma.

Hue

This is another word for the actual colour itself: red, blue, green and so on. Primary hues are yellow, red and blue. These cannot be mixed from any other colour. Secondary hues are orange, green and violet. They are made by mixing pairs of primaries. Finally, tertiary hues are intermediate colours made from mixtures of a primary and a secondary hue.

This colour circle shows some general mixing possibilities. The three primary colours are the largest circles; secondaries are the smaller circles, and the tertiary colours are the smallest. Mixing opposite hues creates neutral colours

Tone

This term refers to the lightness or darkness of a colour compared to a grey scale. All colour can, of course, be lightened and darkened by the addition or reduction of water. However, care must be taken when adding black or grey to darken certain colours, since this can also modify the original hue.

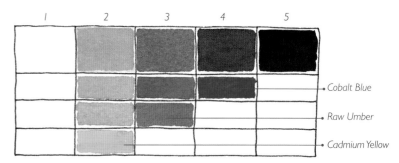

This diagram illustrates the tonal capabilities of three colours as compared to a grey tonal scale. The darkest I could make Cobalt Blue was equivalent to value no.4, with Raw Umber equal to value no.3 and Cadmium Yellow, being an inherently light colour, lying somewhere between values nos.2 and 3

Temperature

Colours can be said to be either warm or cool. Yellows and reds tend to appear warmer; greens and blues, by comparison, appear cooler. As a general rule, warm colours will seem to 'advance', while cooler colours will tend to 'recede', although such rules should not be taken too literally.

Here I have laid out the seven colours of the spectrum in a random order. Notice, by comparison, how the warmer colours tend to come forward

Chroma

This term refers to a colour's intensity, or amount of saturation. It is totally distinct from its tonal value (lightness or darkness) and the two terms should not be confused. For example, Alizarin Crimson and Viridian are 'high chroma' colours compared to, say, Yellow Ochre, which, although lighter in 'tone', has a more muted appearance and is therefore of 'lower chroma'.

Yellow Ochre Alizarin Crimson Viridian

When selecting colours, the relative intensity of individual hues will affect their suitability for use. This should also be considered in relation to other characteristics

Subject led colour

Before you begin a painting, make a conscious selection of the colours you are going to use, rather than randomly dipping into this colour or that as you go along in the vain hope that everything will work out. The most common approach is to be led by what you see in the subject and then choose colours that will create the closest matches.

This is the method I used in the painting right. Select the colours on your palette that are the nearest to the colours in your subject and paint by matching the colours to your subject in hue, tone and intensity, applying them in the most direct way that you can. As a general rule, aim to use fewer colours by creating secondaries, or tertiary mixes, from the colours you have already selected, rather than introducing unnecessary additional ones; this will give a painting greater cohesion. To reduce the possibility of your colours becoming muddy, try to minimize any overpainting and, to begin with, never mix more than two colours together in your palette prior to applying them to the paper.

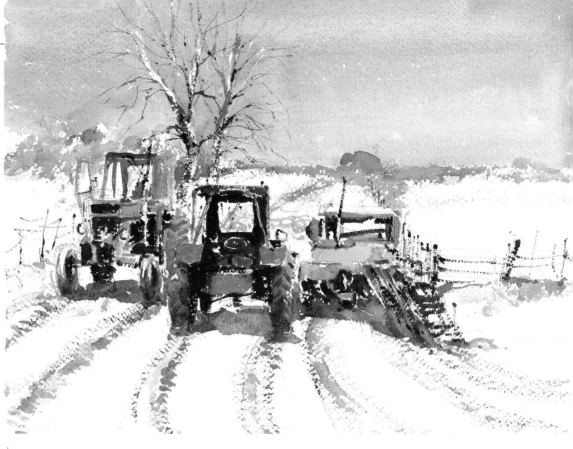

Tractors in the Snow
28 x 38cm (11 x 15in) on 300gsm Rough surface Fabriano paper
Beginning with the tractors, I matched each area of colour and its relative tonal value as closely as I could to the actual subject, completing one tractor at a time. I then added the trees, sky and background features. The only overpainting is the lines denoting the tyre treads

Preselection

An alternative approach is to disregard the actual colours in the subject, in preference for a preselected range, as in the painting right. These may be a group of colours that you find more personally satisfying, or through which you might wish to create a particular mood. Interesting colour groups can be found by making a series of separate colour swatches. Choose colours by trial and error, until something looks more appealing. The chance discoveries made in this way may ultimately prove to be more rewarding than rigidly sticking to a predetermined plan, and will move your colour experience forward.

Raw Sienna

Alizarin Crimson

Cerulean Blue

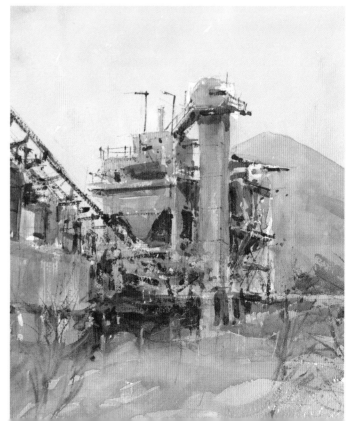

Industrial Plant
30 x 33cm (12 x 13in) on 400gsm Not surface Saunders Waterford paper
For this painting I used the following preselected colours: Raw Sienna, Alizarin Crimson and Cerulean Blue. This enabled me to create fairly intense oranges with Raw Sienna and Alizarin Crimson, and soft greens with Raw Sienna and Cerulean Blue. Adding touches of each colour to mixtures of the other two produced a range of muted greys

The Energy of Limited Palettes

One of the most productive ways of learning to handle colour is to begin with a limited range. This will simplify your mixes, while at the same time forcing you to stretch your colour combinations to their maximum potential.

Two-colour palettes

Monochrome watercolour studies are limited solely to variations in tonal value (lights and darks). The inclusion of a second colour will extend the parameters to include variations in chroma (colour intensity) and temperature (warm or cool). So even the simplest and most basic colour groups, consisting of just two colours, can offer a wide range of possibilities resulting from variations in tone, chroma and temperature. Complementary, or near-complementary, colours (opposites on the colour circle) are potentially the most striking, since they maximize temperature variations and combine to make a series of middle-greyish neutrals. This will reduce the likelihood of colours becoming muddy as you work with them. I suggest that you make some small colour swatches first, to explore the potential of your proposed colour mixes.

Palette 1: Burnt Sienna and Ultramarine Blue

This is an excellent two-colour palette consisting of a warm earth red/orange and a contrasting cooler blue. It is a balanced pair with neither colour dominating the other. The two colours combine to make a range of greys comparable with the colours of nature. This combination makes an ideal sketching palette, as in the painting right. When using a two-colour complementary colour palette, you will have to translate the relative temperature range of the colours in your subject into the limited capabilities of your chosen palette. Follow the same procedure as when working tonally: establish the warmest and coolest colour extremes first, then fill in the middle areas of greys, asking yourself whether they are predominantly warm or cool.

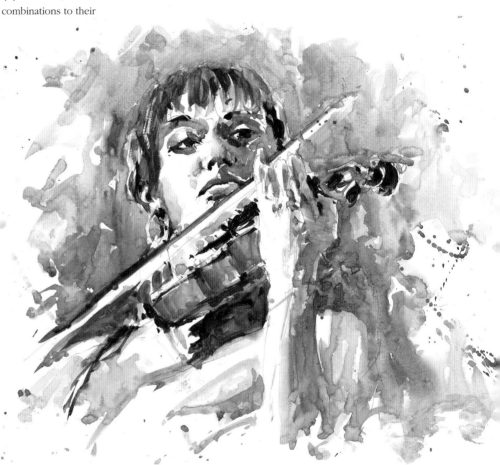

Concert Soloist
30 x 40cm (12 x 16in) on 250gsm Bristol Board
Working tonally, I matched the values in the painting to those in the subject, while adjusting the temperature variations in my mixes. To bring the figure forward, I painted it generally warm, with the hair as the warmest area, while keeping the background predominantly cool. I juxtaposed cool shadows in the flesh tones to add vitality

Burnt Sienna Ultramarine Blue

Palette 2: Burnt Umber and Neutral Tint

This is an alternative complementary combination. Here the brown is not as warm as the Burnt Sienna in Palette 1, so it balances well with the more muted grey of Neutral Tint, giving a generally 'quieter' appearance overall. This makes an ideal sketching combination. Even with two-colour palettes, temperature variations can be used to create different results. By allowing one colour to be more dominant, it is possible to influence the overall temperature in a painting so that it is perceived to be predominantly warm or cool. I have produced two paintings of the same subject below, in each case making one colour more dominant. I recommend that you produce some studies of a simple subject of your own choice, like the examples here, in which you try to vary the temperature relationships. This will give you experience in controlling your colour mixing to create predetermined results. The process of allowing one colour to be more dominant can also be used successfully when working with extended colour palettes consisting of three or more colours.

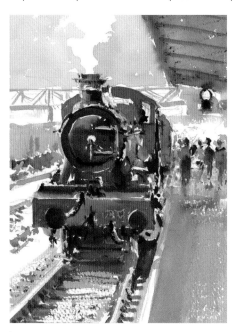

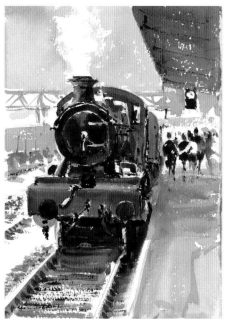

Steam Engine 2

30 x 20cm (12 x 8in) on 300gsm Rough surface Saunders paper
Here I took the opposite approach, choosing Neutral Tint as my dominant colour, to which I added varying amounts of Burnt Umber to slightly warm the mixes. Although tonally both images are virtually the same, the general effect here is a cooler version of the subject

Burnt Umber Neutral Tint

Steam Engine 1

30 x 20cm (12 x 8in) on 300gsm Rough surface Saunders paper
Here I chose Burnt Umber to be the dominant colour, to which I added touches of Neutral Tint to reduce the intensity of my mixes. Although in the sky and distant background forms there are some areas of Neutral Tint on its own, the overall effect is a warmer version of the subject compared to the second example

Palette 3: Sepia and Indigo

This complementary combination shows an overall cooler alternative. Here both the brown and the blue are comparatively cool, and the general effect is predominantly cooler than the previous two palettes, as in the painting right. For still more alternatives, try interchanging the colours I have suggested or experiment with additional combinations of your own choice.

Sepia Indigo

Boat Yard

28 x 38cm (11 x 15in) on 300gsm Rough surface Fabriano paper
Provided the tonal values are correct, paintings can be produced in any colours we choose, in order to create a different emotional response in the viewer. I have exaggerated the cool temperature here by incorporating two inherently cool colours, so even though the subject is bathed in light, we perceive it as being cold

Further variations can be achieved by extending two-colour palettes towards more intense complementary colours and by using different coloured toned papers.

Palettes 4 and 5: Red/Green and Yellow/Violet

The remaining alternative complementary combinations of red/green and yellow/violet require more subtlety in mixing, since they tend to be more intense colours. As complementaries they will combine to make a range of near-neutrals, but with these mixes unequal amounts of the two colours are required. Only a touch of red will be needed to neutralize a green, and a mere hint of violet will grey off a yellow. The success of these palettes lies in balancing touches of pure colour against the greater areas of warmer or cooler neutrals used throughout the rest of the painting. The general field of the image needs to be fairly neutral, painted in near-middle greys. You should then play down the intensity of each colour with touches of the other, so that neither is allowed to become too dominant. Tints, tones and shades made from the two colours should be used for most of the painting, against which purer touches of the two key colours will appear to sing out. For these effects to work, it is essential to keep your colours absolutely clean. In the painting right, I used Alizarin Crimson and Viridian. These are two high-chroma (intense) complementary colours. The challenge was to keep each colour under control by reducing its intensity with touches of the other.

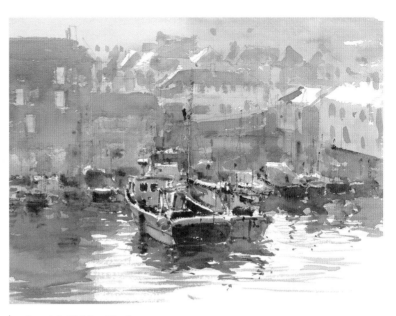

Cornish Fishing Harbour

28 x 38cm (11 x 15in) on 300gsm Rough surface Fabriano paper
I chose these colours for this subject to demonstrate a red/green complementary combination and to illustrate how we can alter the appeal of a painting by using what might at first be considered fairly unlikely colours. I kept my more neutral (greyer) mixes for the general field of the painting, and used more intense, darker versions of the two colours in the foreground

Alizarin Crimson Viridian

In the painting left, I used Raw Sienna and Cobalt Violet. Adding violet to some yellows produces a green, but the earth yellows of Yellow Ochre and Raw Sienna take on a muted appearance. Since violet is a very intense colour, only a hint is needed to neutralize the yellow, whereas a relatively large amount of yellow is needed to grey off violet. This palette is best used to create atmospheric effects, although take care that images do not appear too pretty or too garish.

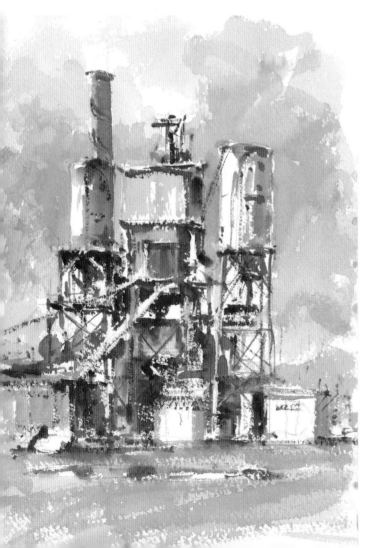

Granite Washing Plant

30 x 20cm (12 x 8in) on Rough surface Saunders paper
I often think that watercolour painting could be more accurately termed watercolour drawing, because much of the time we are actually drawing with the brush – and this image is a perfect example. The complexity of the structural forms here almost defied understanding, so I placed in the various elements as tonally understated shapes, reducing my colour mixes to a range of near-neutrals

Raw Sienna Cobalt Violet

Using toned paper

Limited palettes work particularly well in
conjunction with toned papers. Here the
process of painting is exactly the same; the
difference is that as the paper is one tonal step
lower than white, all colour applications will
be modified by the colour of the paper itself.
I find toned papers to be less forgiving than
other watercolour papers, because the colour
of the paper reduces the opportunity to use the
transparent qualities of the medium. This makes
blending and pushing colours around slightly
more difficult. For the best results, simplify your
colours to one or two, keep your overpainting
to a minimum, and paint as directly as you can,
adding back any small touches of highlights
with white gouache or chalk, if appropriate.

In the painting right, I used Burnt Sienna and
Lamp Black in conjunction with a grey paper,
so the colour variations are limited to shades
of browns set against greyish neutrals. This
painting is all about lost and found edges; it
was crucial to define the forms in the light with
precise drawing, which I have exaggerated by
darkening the background shape against the
hair and shoulder. I did not want the spectacles
to be too dominant, so I blended them into the
surrounding forms in some places, leaving them
as the colour of the paper where they caught
the light. When the image was completed, I
reinforced the shape of the glasses with a touch
of brush drawing where necessary.

Burnt Sienna _Lamp Black_

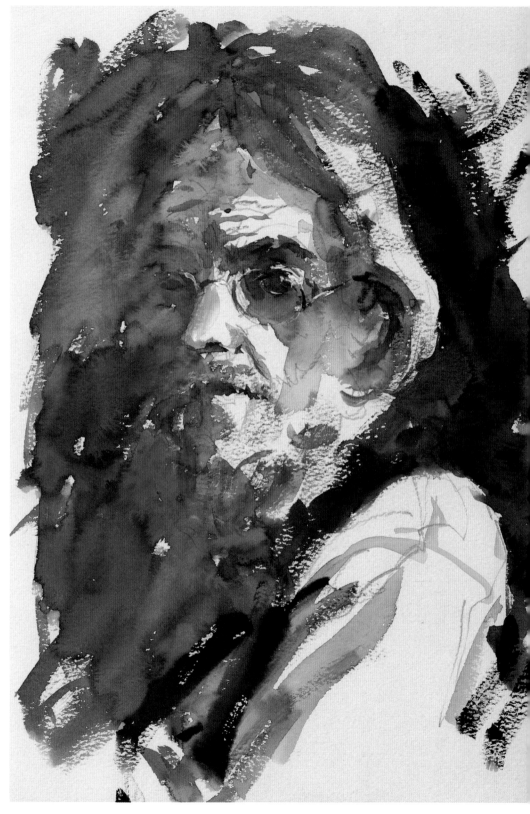

Male Portrait
36 x 28cm (14 x 11in) on 300gsm grey-tinted
Bockingford paper
_Here I used my warmer colours for the face and
more neutral mixes for the darker background areas,
cutting around the lit forms of the hair and shirt
with hard-edged shapes. Blending the shaded side of
the face into the background added to the intensity
of the lighting in the image_

Using Base Colours

Working with a limited group of core, or base colours, will provide uniformity and also help you to avoid those muddy, stale colour passages that are brought about by the excessive mixing of too many colours.

Colour groups

When thinking of colours, it is preferable to consider them in terms of groups rather than in isolation. This way you will be able to appreciate their mixing capabilities in relation to that particular group. If any of those colours are then used in another group, or others are substituted into the original group, you will be able to see their effect on the scope of the group as a whole. For example, if you were to substitute Cadmium Yellow for Yellow Ochre in a Yellow Ochre, Burnt Sienna and Ultramarine Blue colour triad, this would extend the colour capabilities by making brighter greens and richer oranges. Alternatively, substituting Cerulean Blue for Ultramarine Blue in the same triad would move the mixing capabilities in another direction, towards softer greens. A useful starting point is to choose just two or three base colours, combinations of which you can use to produce most of a painting. You could then add other, smaller touches of

localized colours as visual accents or highlights if needed. Unless done within the context of an overall colour structure, adding in extra touches of pure colour should not be relied upon to brighten up an otherwise lifeless image. In fact, the very opposite will usually be the best course of action. If you feel that your paintings have a tendency to look dull and lifeless, I suggest that you first try reducing the number of colours you are using.

Strollers in Paris
26 x 36cm (10 x 14in) on 300gsm Rough surface Fabriano paper
Here I used all 'high key' colours that were capable of producing a range of bright vivid hues, including bright greens, rich oranges and some purples and lavenders. Some higher-key colours can appear rather brash, but careful use of more neutral mixes will offset any tendency for the brighter colours to overpower the painting

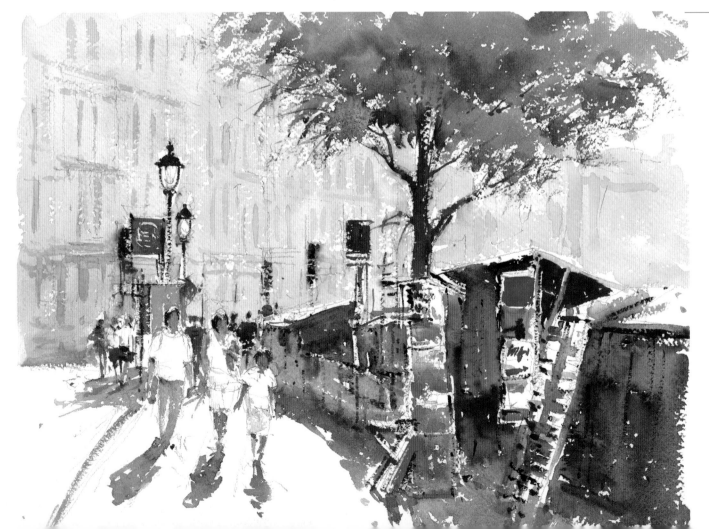

High-key and low-key palettes

The term 'key' refers here to the chroma, or intensity, of a colour; this characteristic will considerably influence the capability of a group of base colours. 'High key' colours are those with the greatest chroma and will create more intense colours when mixed. 'Low key' colours are those of lower chroma and will combine to create generally more muted colour mixes. This does not refer to the tonal value of the colour (lightness or darkness), which is a different and quite separate characteristic. Also, it does not necessarily mean that paintings produced entirely from low-key colours will be dull or uninteresting. It is quite usual for colour palettes to be made up of combinations of both high- and low-key colours, but the general effects of paintings produced in each of these colour keys will be noticeably different.

High-key triad

In the painting left, I used Alizarin Crimson, Cadmium Yellow Light and Ultramarine Blue as my core colours. Here my aim was to balance touches of pure colour against a more general muted range of neutrals in the general field of the painting.

Low-key triad

In the painting right, my colour range was Light Red, Raw Sienna and Neutral Tint. This is a low-key palette, made up of colours with low chroma, and it is basically a muted version of the first example. Here, the warmer colours combine to give a range of muted oranges, with the greens being restricted to a fairly suppressed grey-green. The coolest colour, grey, can appear bluish when seen against the overall warm field of the painting.

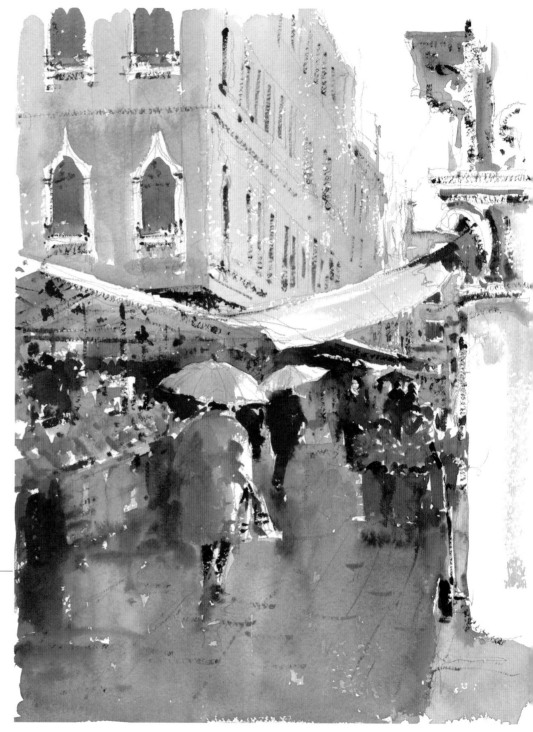

Venetian Market
36 x 26cm (14 x 10in) on 300gsm Rough surface Fabriano paper
Working with restricted palettes forces you to be more thoughtful, so the challenge here is to extend your colour mixes to get as much as you can from your relatively limited colour choice

Achieving Power with Neutrals

Neutral colours are essentially greys, but it is best to think of them as a range of greys extending across the entire spectrum rather than one single grey. Neutrals are an indispensable ingredient in the artist's colour repertoire, and learning to use them effectively is fundamental to enlivening a painting. Their power lies in providing a balance, against which touches of purer colours will appear to glow.

Mixing greys

Compared to greys straight from the tube, mixed greys will display a pearly, luminous character, more like the actual colours of nature. The most straightforward way to mix them is with any primary colour and its complement, for example, orange with blue, red with green, or yellow with violet (as illustrated earlier in this chapter). Here the colours tend to cancel each other out to form a mid-grey, which will lean towards one of the two original colours. Mixes can be adjusted in either direction, to warm or cool them, simply by adding a little more of either of the original colours. Alternatively, near-neutrals can be made by mixing unequal amounts of three primaries, from which a whole variety of more subtle, delicate greyish hues can be made. These will vary depending on the actual colours used. In the swatch far right, I used Cadmium Yellow, Alizarin Crimson and Cobalt Blue to make the range of six spectral greys right, each of which tends towards a particular primary or secondary colour. I placed a circle of diluted Lamp Black in the centre, for comparison.

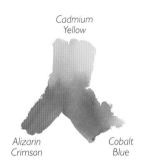

Primary colour palette from which the spectral greys left were created

Comparative spectral greys
When mixing greys, the key is to use disproportionate amounts of each of the three primary colours, so that you can then pull the mixes towards any of the six alternatives shown. If the general field of a painting is limited to neutrals, brighter touches of more intense colours will appear to shine

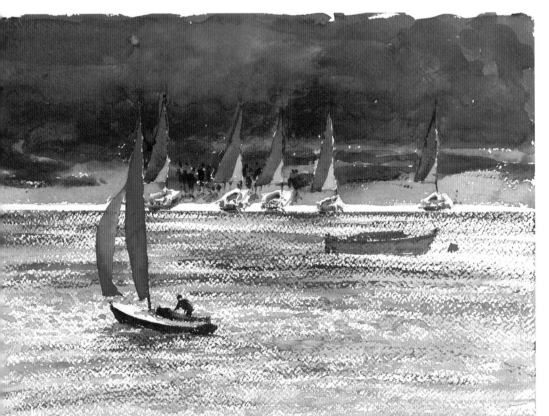

Sailing on the River Dart
26 x 36cm (10 x 14in) on 300gsm Rough surface Fabriano paper
To create the illusion of luminosity, as in the foreground red and orange boat sails here, touches of pure colour need to be restricted to small areas and contained within a near-complementary neutral field. Here I used three primaries, which I mixed to greys for most of the image, keeping my pure colours for the various boat sails

Using black

Although some artists frown upon the use of black, I consider it to be a valuable asset, both in its own right and for mixing with other colours – although care must be taken to use it in moderation. Black works well as the balancing cool colour in a limited palette of orange/browns, specifically Burnt Sienna, Brown Madder Alizarin or Burnt Umber, as in the painting right. The danger of using black to darken other colours is its tendency to deaden some mixes and alter the colour of others. As can be seen in the swatches below, touches of black added to green, blue or violet, for example, will not change the basic hue, although the general intensity of the original colour is gradually reduced as more black is added. However, when black is added to red, it will eventually turn it into a dirty brown, or even violet, depending upon the particular red used. Black added to orange will turn it into a brown, while adding the slightest touch of black to yellow, the least tolerant colour, will immediately turn the yellow to green.

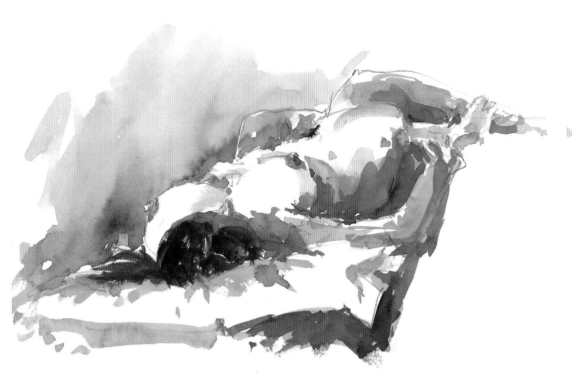

Jayne
23 x 30cm (9 x 12in) on 300gsm Not surface Saunders paper
I used Burnt Sienna and Lamp Black as a convenient warm/cool palette for this figure sketch. Lamp Black on white paper appears bluish when set against Burnt Sienna, which itself appears richer in combination with black

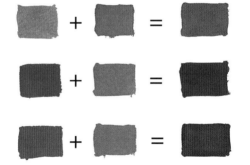

Green, blue and violet retain their hue when darkened with black. Adding back an equivalent amount of the original colour helps to prevent the mix becoming overpowered as it is darkened

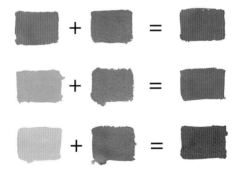

Red, orange and yellow undergo a change of hue as black is added. This is not necessarily detrimental; some beautiful colours can be created in this way

Mixing black

The darkest neutral, almost a black, but again displaying more energy than a tube black, can be mixed from Alizarin Crimson and Viridian (a red/green complementary colour mix), with a slight touch of Burnt Sienna. To fully understand the significance of these recommendations, it is essential to try out the suggested mixes to experience how the colours behave for yourself.

Lamp Black

Alizarin Crimson + Viridian + a touch of Burnt Sienna

Colour swatches comparing Lamp Black, on the left, with a mixed black, on the right, made from Alizarin Crimson, Viridian and a touch of Burnt Sienna

Utilizing Colour Effects

The emotive appeal in paintings can be significantly increased by using certain colour effects. This will enable you to begin to move your paintings towards more personalized interpretations, taking them beyond mere faithful representations of your subjects.

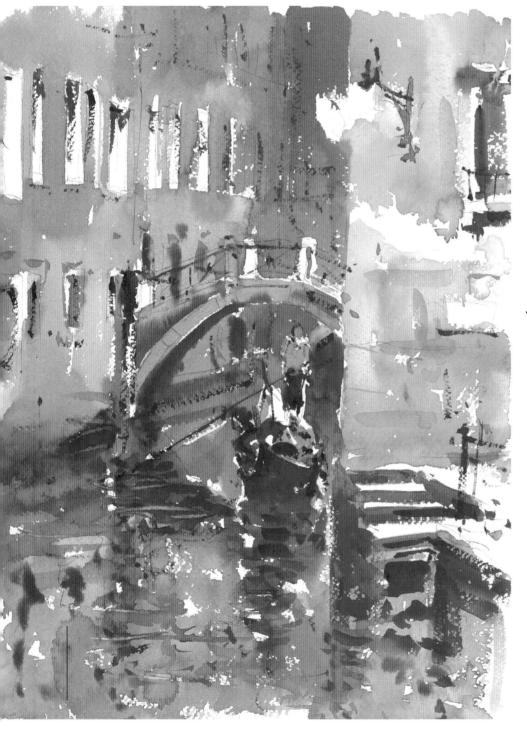

Colour harmony

Two areas in which colour can have a direct influence are in the creation of harmony and discord, and the degree to which each of these characteristics occur will affect the general tenor of a painting. Colour harmonies are created by combining hues that are 'in tune' with each other and thus relate in a calm and quiet way. With harmonious colour relationships, the eye moves easily between the colours of adjacent forms without abrupt changes. Compared to the generally high-intensity colours in your painting palette, the colours of things in the natural world consist, in the main, of ranges of muted spectral greys.

Analogous colours

These are colours that are in close proximity to one another on the colour circle (normally no more than three steps apart) and that, when combined, create a feeling of peacefulness and unity. Analogous colours can also be selected to give temperature variations, depending on where they occur on the colour circle. Images produced with a palette of related blues, for example, will portray a predominantly cooler, brighter effect as compared to the same image painted in warmer and more muted related ochres and browns. By mindfully selecting the colours you use, you can considerably influence a painting's emotional appeal. In the painting left, I used a range of warm colours to portray the tranquillity of the scene.

Venetian Evening
38 x 28cm (15 x 11in) on 300gsm Rough surface
Fabriano paper
Selecting particular colours will enable you to influence a painting's emotional appeal. Here I chose a range of warm analogous colours, namely Raw Sienna, Burnt Sienna, Cadmium Orange, Permanent Rose and Cadmium Red Light, to convey the serenity and warmth of this quiet evening scene

Colour discord

An alternative colour characteristic is the effect of discordancy; this is the opposite of colour harmony. Discordant colour combinations will appear to clash or compete with each other, so they can be used to create impact and excitement. To understand how colours can be made to behave in this way, consider the natural order of the colours of the spectrum, as a seven-value tonal scale from yellow, the lightest value, through to violet, the darkest. Colour discords are made by choosing any two colours and reversing this natural tonal order; for example, placing a lighter-value blue within a darker-value red, or placing a lighter-value red within a darker-value orange. This effect will also be noticeable when the tonal values of the two selected colours are exactly the same.

The colour swatches below show examples of other discordant relationships. The left-hand column shows the results of placing a lighter-value green within a darker-value orange, a lighter-value indigo within a darker-value green and a lighter-value violet within a darker-value red. In the right-hand column, I have shown this arrangement with tonally reversed blue/orange, red/green and violet/yellow complementary combinations. The effect of discordancy will be more pronounced with complementary pairs, although the violet/yellow discord is the most difficult of all to create in watercolour. Since yellow is such a tonally light colour, violet needs to be diluted to almost white to make its value compatible.

The seven colours of the spectrum, laid out here in their natural tonal order, from yellow, the lightest, through orange, green, red, blue, indigo and finishing with violet, the darkest

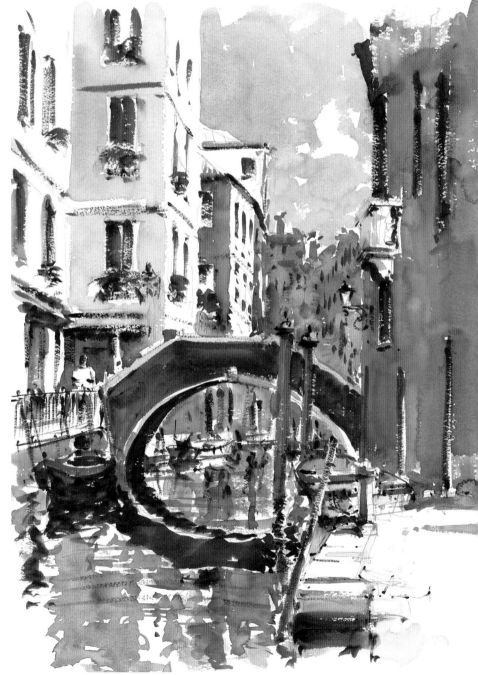

These are examples of discordant colour combinations in which the relative tonal order of the colours in the spectrum has been reversed, making the colours appear to clash. Notice that the right-hand complementary pairings appear more intense

Canalside Walkway
50 x 36cm (20 x 14in) on 640gsm Not surface Saunders paper
Compared to the first example, these colours give the image more impact. I used a complementary colour combination of Burnt Sienna and Ultramarine Blue, blending touches of each colour into areas of the other to keep the painting surface alive and to intensify the discordant effect

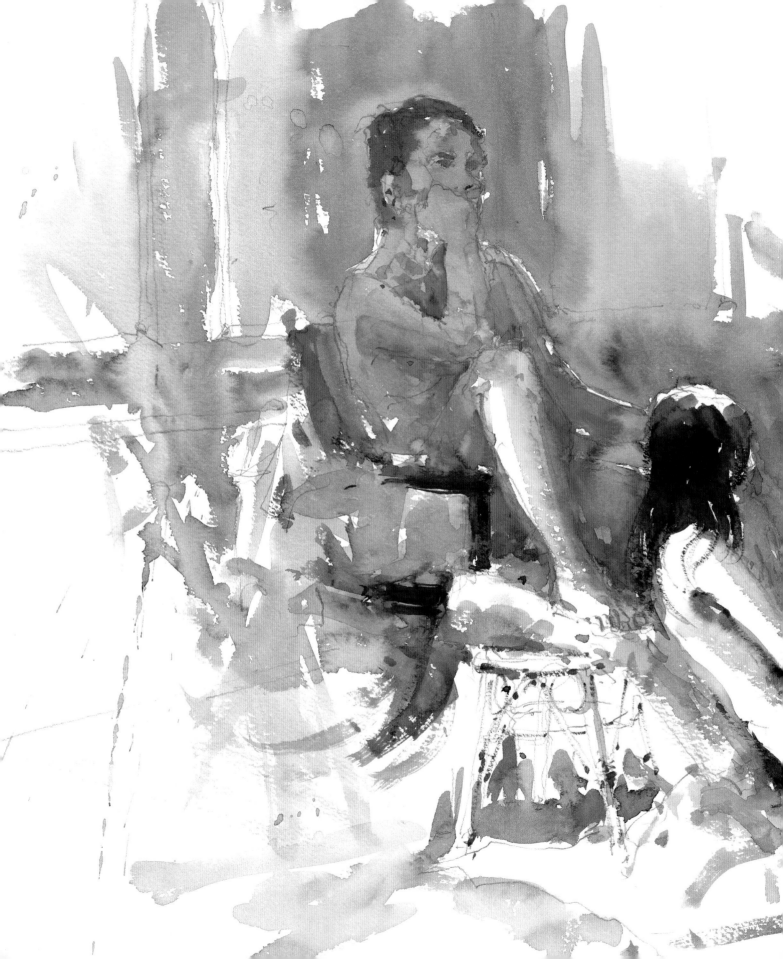

Chapter 6

Heightening Impact with Design

D esign refers to the way elements are put together within a picture; it can include lines, shapes, tones, colours, contrasts and textures. The essence of good design is simplicity, which leads to paintings in which the subject is stated in a clear and concise way. How these elements then relate to one another creates movement. Both design and movement are dynamic qualities that can be manipulated to produce greater impact.

Double Pose
36 x 53cm (14 x 21in) on 300gsm Not surface
Bockingford paper

Establishing a Focus

For clarity, paintings need a central point of interest, a place to which the eye is naturally led. Without this, they can appear vague and ambiguous, so it is essential to relate all elements within the linear design towards this end.

Layout and composition

Although rules in painting should never be followed too stringently, it is generally true that placing a focal feature in the middle of an image is less visually appealing than positioning it off-centre. A convenient rule of thumb is to divide the picture surface into thirds, both vertically and horizontally, then place the most important feature at either of the four balance points where these dividing lines intersect (shown in blue on the diagram). Another equally satisfactory although slightly less convenient alternative, based upon an approximation of the proportions of the Golden Section, is to use the proportion of 5 to 8 (shown in red on the diagram). Locating your principle features on or between these intersections is a worthwhile starting point for building a balanced composition.

In the painting below, I placed the nearest mast on the ship (my focal feature) on a vertical division line, in the ratio of 5 to 8 across the picture. I then placed the most dominant horizontal (the horizon line) one-third of the way up the paper.

Locating focal features on or between one or more of the highlighted balance points will lead to a more harmonious composition

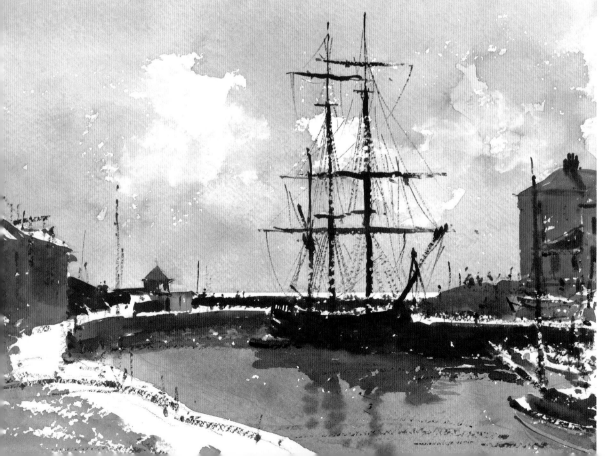

Tall Ship
28 x 38cm (11 x 15in) on 640gsm Rough surface Fabriano paper
Placing dominant horizontal and vertical elements on focal axis lines will enable you to create images in which things appear to sit in the right places, without looking awkward or as if they are falling off the edges of the paper

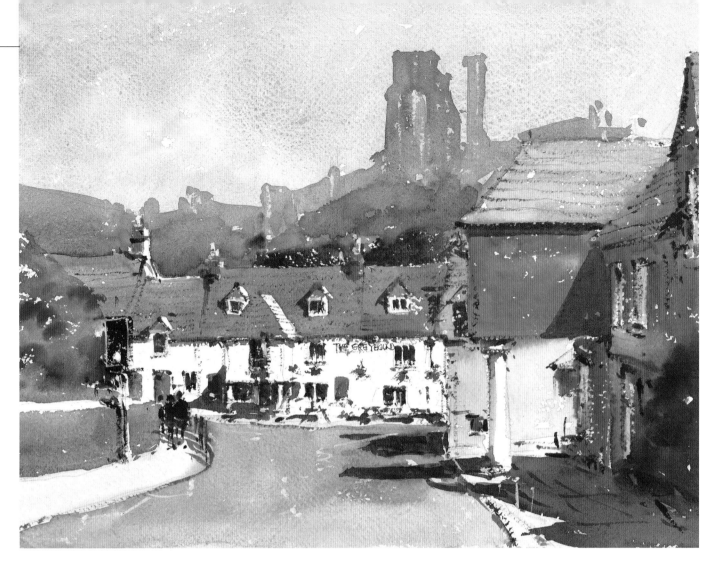

Defining factors

When designing a composition, there are two points to bear in mind: the arrangement of the image on the painting surface, and the size of the painting surface itself. Before you begin a painting, you should be absolutely clear about what you want it to convey. It will then be far easier to decide upon the relative importance and arrangement of the various elements within it. For example, consider whether the central point of interest is to be isolated, with merely a hint of a background, whether it will be contained within a similar group of objects, or whether it is to be one element in a mixed assortment of things. You should also decide on the size of the focal feature in relation to the painting surface itself. Should it occupy most of the painting surface, be set into the middle distance, or placed in the background? Another consideration is whether the image is best suited to a vertical or horizontal format. These issues will affect the outcome of a painting, so should be fully thought through at the outset.

Locating the focus

The location of your centre of interest within the overall depth of the picture will affect how much supporting information is needed. If the focal object is in the foreground, as in a figure study, for example, all elements behind it will probably be less important and might therefore be played down. Alternatively, where the focus is set in the background or far distance, as in a sky study, then only a hint of the foreground and middle distance may be necessary to anchor the sky and create the illusion of space.

In the painting above, my focus is the row of white buildings lying in the middle distance. To retain this, I played down the importance of the castle in the background, by reducing it to little more than silhouetted shapes. I also lessened the dominance of the left- and right-hand foreground features by simplifying and understating their forms, to prevent the eye lingering in that part of the picture and being distracted from the focal feature.

Corfe Castle
28 x 38cm (11 x 15in) on 300gsm Rough surface Fabriano paper
To improve the clarity of an image, decide on which focal plane your central point of interest lies (foreground, middle distance or background). Then simplify the rest of the image by understating the forms, or leaving things out altogether. This is similar to reducing the depth of field on a camera, so that only the subject itself remains in focus

Reducing the content or changing the format of an image can strengthen the focus and simplify the design. The appeal of many paintings is lost because they attempt to show too much, so they end up looking like several pictures painted in one. This can make them appear muddled and overcomplicated.

Preliminary sketches

Experiment by making preliminary compositional sketches to try out alternative arrangements and image formats, rearranging or omitting features if you think this improves the overall design. Alternatively, try cropping an image to reduce its complexity. Lay a couple of L-shaped pieces of card over the original drawing or reference photographs and adjust them to isolate different areas in turn; this may highlight several viable and previously unconsidered options. My original drawing, right, is an appealing image, but it is bustling with visual activity. Although the linear pattern of the composition leads the eye towards a focal point (the dark opening in the background building), this is weakened by the overall complexity of the image. Cropping the image, as shown in the first example below, strengthens the focal point. I changed the layout to a vertical format and placed the right-hand building edge on a vertical focal axis line, and the top edge of the row of boats on a horizontal focal axis line. In the second example, below right, I cropped the image from the left, moving my central point of interest to the café sunshades in the middle distance. This image still appears quite busy, so the dominance of the foreground boats and right-hand building façades would need to be played down in any subsequent painting.

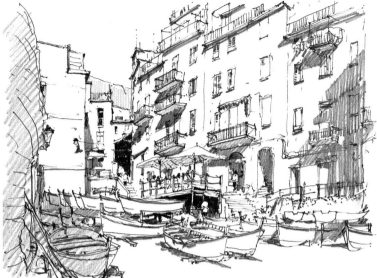

The Slipway
30 x 40cm (12 x 16in) pen and pencil sketch on cartridge paper

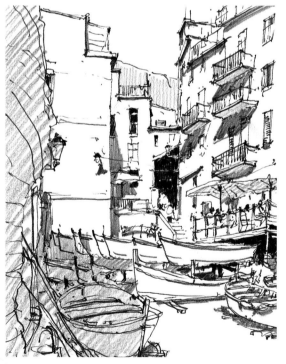

Cropping alternative 1
Often a reduction in content and a change of format can help to rejuvenate a composition

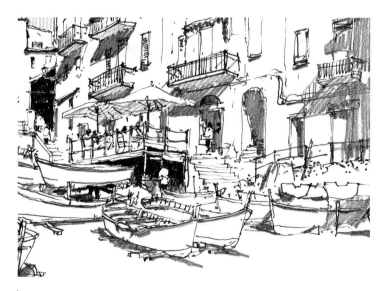

Cropping alternative 2
Busy images often contain alternative potential focal features, which will enable you to produce a variety of composition options. The overall visual depth in this image is relatively short, compared to the previous painting (on page 71). In order to maintain the clarity in the focal features, it would be essential to understate the foreground features to prevent them becoming too dominant

Movement and rhythm

Movement is created from the way in which the planes and surfaces in a painting relate to each other across the picture surface. This sets up a rhythm, which might be quick or slow, flowing or staccato, to add to the surface interest. Movement can occur in all directions – both two- and three-dimensionally, or within, around and through shapes and forms – much like the action on a theatre's stage. The two-dimensional areas of tone and colour that make up the elements in a painting are also just planes and surfaces that, in a unified whole, appear to be three-dimensional, lying either towards the foreground or the background planes. In the painting right, I generated surface movement by letting some of the edges blend into one another to link overlapping forms. I let the light spread out into adjacent features, by losing the edges of some forms. I also used light and dark and temperature and intensity variations in my colour applications, as a way of attracting and repelling the viewers' eye.

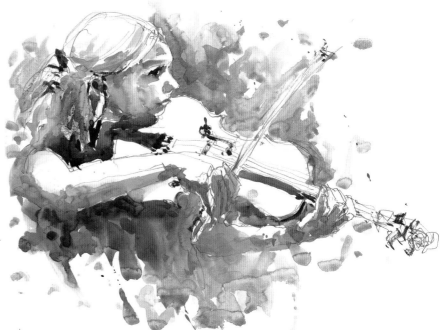

Viola Player
28 x 40cm (11 x 16in) on 220gsm Bristol Board
The method of applying the medium can influence the feeling of movement across the surface planes. In this painting, I used watercolour's inherent fluidity to convey a sense of the energetic movement of the musician, while linking overlapping planes of similar tonal value and leaving some exit routes across adjacent forms for the lights

Direction of movement in **Viola Player** *(right)*
The longer flowing line links tonally similar forms; the shorter lines indicate openings for the lights to move out into adjacent planes

Creating tension

The movement of planes can also be used to create tension, so that one area appears to have a pull, or exert a force, on another. I have illustrated this in the diagrams below. In the painting right, I used the thrust between the planes to generate tension. The empty space below the narrow, horizontal blue line on the right-hand side of the image appears to be supporting the full weight of the figure, thus creating a tension in the image. If you place your hand under this line, the image loses its suspense. Cropping the top of the head also increases the impression of force.

Balance
Here, each side of the image reflects the other and is in equilibrium

Tension
In this example, one side of the image exerts an invisible pull on the other and is out of balance

Young Woman
26 x 36cm (10 x 14in) on 300gsm
Saunders Not surface paper
Tension can increase a painting's impact. In this image, the areas of empty space emphasize the thrust from the figure, while at the same time allowing the painting to breathe

Using Directional Indicators

This is a design concept that we can use to help maintain and reinforce a centre of interest. Beginning with a clear idea of what you want a painting to be about is essential. You can then construct an image to draw attention to your chosen focal features. This can be enhanced by incorporating combinations of directional indicators.

Linear indicators

Lines in drawings are used to delineate the outlines of forms to denote their separation. But lines can also be used as directional pointers to steer the eye around an image towards the focal features. They can be strong, precise lines, formed by the continuous edge of a single form, such as the line of a road or a riverbank. Alternatively, they may be weaker, less direct lines, formed from the combination of several forms, such as a meandering line, which might link the edges of overlapping shapes across a group of objects. Lines can also be used to create the optical effect of three-dimensional space and distance, using linear perspective.

In the foreground buildings in the painting below, I used the optical effect of convergence (where parallel lines appear to get closer together, or even touch at the horizon) to achieve the illusion of distance, in order to lead the eye towards the tall tower of the Corn Exchange building, my focal feature. The contrasting vertical linear form of this building also acts as a buffer against the prevailing horizontal forms leading towards it. The foreshortening and diminishing effect of the window and door openings in the oblique buildings also create the illusion of distance (this is the optical effect that makes objects of the same height and distance apart appear to be closer together and to reduce in size as they recede from view).

The drawing below illustrates the effects of linear perspective in this image. The 'eye line' is an imaginary horizontal line that represents the level of your own view of the subject, which in this example is the height of a standing figure.

City Street

38 x 28cm (15 x 11in) on 300gsm Rough surface Fabriano paper
Linear indicators are a useful means of drawing the eye towards a focal feature or creating the illusion of distance in paintings. Here the converging horizontal lines of the buildings on each side of the street act as powerful directional indicators

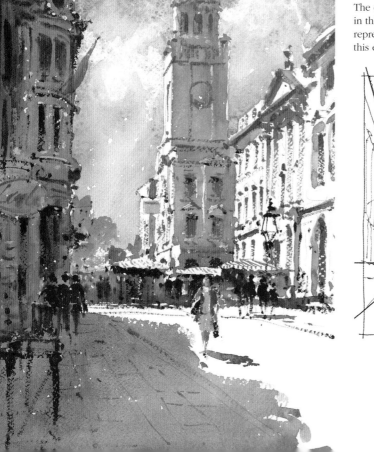

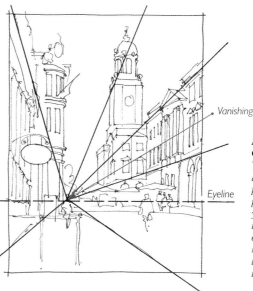

Vanishing point

Eyeline

Linear perspective in City Street *(left)*
To create the illusion of distance, first draw in the position of the 'eye line'. All planes and surfaces within your subject will then recede to vanishing points located on this imaginary line. In many images, these may terminate at points outside the perimeter of the image

Tonal indicators

Although light and dark values are instrumental in describing basic three-dimensional forms in a painting and create the impression of light and space (as dealt with in Chapter 4), they can also be used as effective indicators to direct the eye towards, and hold attention on, the focal features. Since areas of the greatest tonal contrast are more immediately noticeable, compared to more subtle contrasts, they can be effective in drawing attention to more dominant elements in a painting. Edges are also important in providing directional accents, with softer-edged shapes appearing less severe than hard-edged forms. Combining hard edges with strong tonal contrasts can further enhance dominant elements in a composition.

In the painting right, notice how the eye is immediately drawn towards the harder-edged shapes of the white cottage in the middle distance. This is because it contains maximum tonal contrasts – namely, the black, hard-edged forms of the windows and shrubbery set against the white paper. In this image, line also plays a useful role, although it is not quite so dominant as in the previous example. Here the converging effect of the oblique foreground buildings on either side of the road accentuates the directional effect in leading the eye towards the focal point. However, the softer and more muted tonal contrasts, compared to the focal feature, reduces their impact, allowing the eye to initially pass over them.

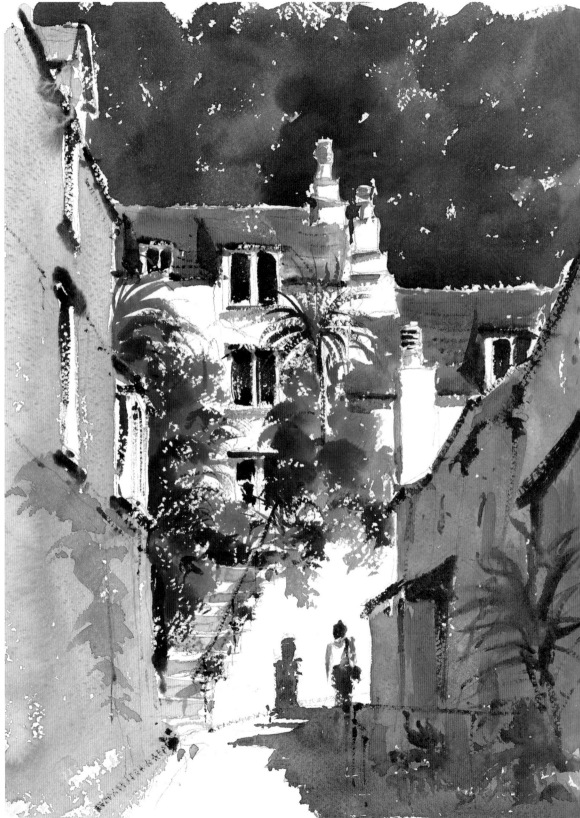

Cornish Cottage
38 x 28cm (15 x 11in) on 300gsm
Rough surface Fabriano paper
Combining hard-edged forms with maximum tonal contrast increases dominance; save these for your focal features and reinforce their impact by incorporating softer, more muted, tonal contrasts in the less important parts of the painting

It can be easy to lose sight of your original concept during the painting process if you get distracted into resolving a painting as a series of separate parts. For that reason, it is essential to continue to see the work as a unified whole.

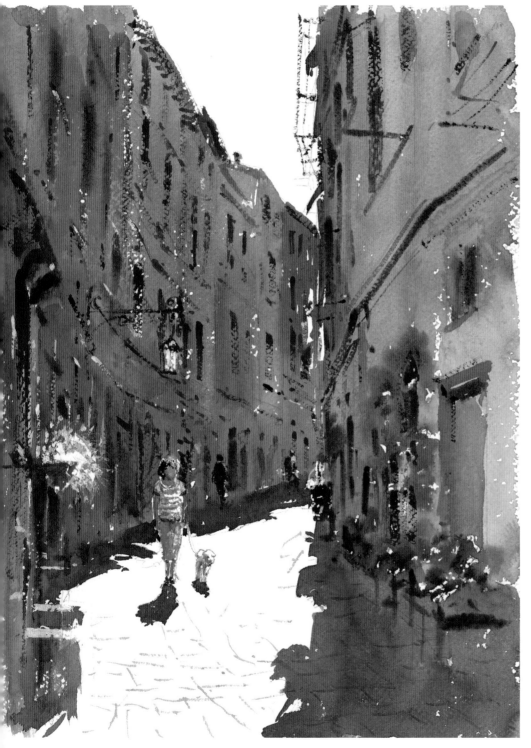

Colour indicators

Accents of pure colour can be used to draw the eye towards focal features, although colour has to be used in a coordinated way for this to work successfully. One method is to use a generally limited palette for the majority of the painting, against which an individual touch of an additional colour can be set. In the painting left, I used a limited low-key palette consisting of Raw Sienna, Light Red and Neutral Tint for the whole painting, adjusting my colour mixes to get as close as I could to the actual colours of the subject. I placed a focal figure at a compositional balance point and used tonal contrast to draw the eye towards it. I further enhanced its dominance by painting it with a single touch of a new colour, Ultramarine Blue. This had the effect of making it sing out against the rest of the image. This small area of light blue, when set against the larger areas of darker red of the buildings around it, creates a discordant relationship that further enhances its presence and makes it appear brighter still. Other colours, such as light indigo or violet, would have achieved the same discordant effect. The key lies in restricting the new colour to a relatively small area and keeping it pure.

Back Street
38 x 28cm (15 x 11in) on 300gsm Rough surface Fabriano paper
To make colour accents appear more dramatic, use a new colour, restrict it to a small area, and do not use it anywhere else in the painting

Exciting the eye

Although considered separately, the directional pointers suggested here are interdependent and can be incorporated within any subject matter. They will also serve to increase the excitement in a painting. Contrasting shapes within the general patterns of an image can also be used to direct the eye around a painting to increase its vitality. When used in combination with dynamic colour passages, the impact will be further increased.

In the painting right, the shape of the area of bright light is a dynamic element in the overall design. My aim in this painting was to show the activity within the market and to portray the feeling of the bright sunlight coming in through the entrance in the distance. I had to do this with an unambiguous focus to avoid the trap of painting a number of pictures in one. I therefore designed the linear composition by placing a focal figure on a compositional balance point, using tonal and colour indicators to add to its impact by using hard edges and maximum tonal contrasts against the white paper. Although I wanted to show the activity within the interior space, I had to be careful to keep the forms generally understated so that they did not detract from the focal feature. To accomplish this, I reduced my tonal contrasts and softened the forms here and there by allowing the edges of adjacent elements to fuse together. I used a fairly low-key palette of Raw Sienna, Light Red, Ultramarine Blue and Indigo and placed a splash of pure Light Red on the focal figure to act as a colour pointer. The variety of descriptive ground shadows produced by looking against the light also helps to create surface movement.

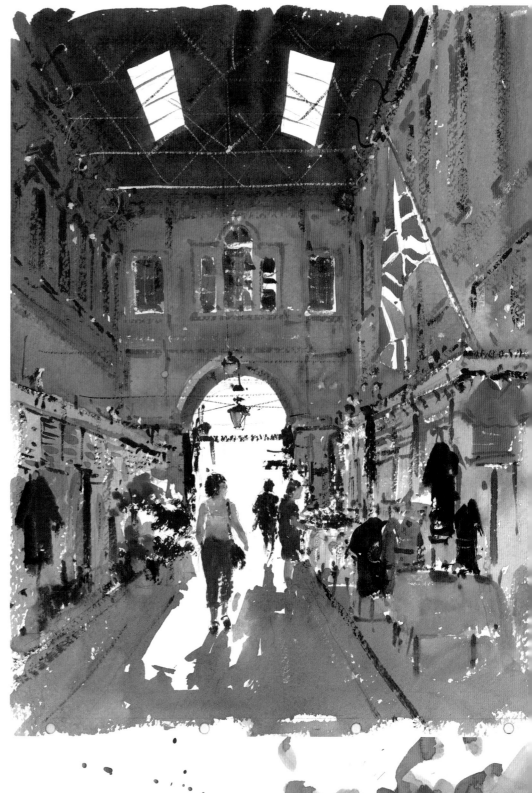

Indoor Market
38 x 28cm (15 x 11in) on 300gsm Rough surface Fabriano paper
This image is full of movement. The linear pattern of the side walls gives the illusion of forward space. This is reversed by the opposite directional ground shadows around the opening, which help to add variety and interest

Strengthening Composition with Design Motifs

The concept of a design motif is as an underlying shape in which elements in an image are invisibly held together. As with the rules of perspective, design motifs are a technical expedient and need to be arrived at instinctively and never contrived or seen as ends in themselves.

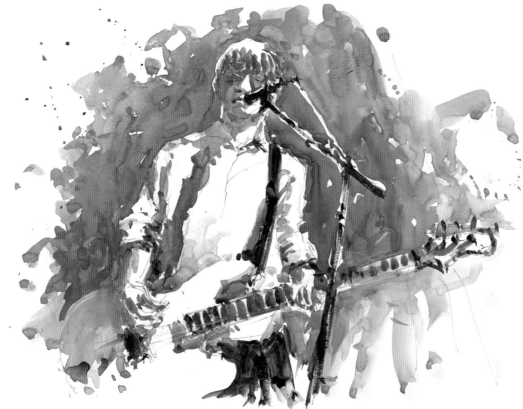

Rock Guitarist
29 x 40cm (11½ x 16in) on 300gsm Rough surface Fabriano paper
Strong images usually have at their core a prominent underlying design motif linking dominant elements. In this image, placing the vertical elements at a slight angle has added to the sense of movement

Overlay showing the dominant design motif in the image

Using design motifs

The most worthwhile way of using design motifs is as a means of analyzing a painting's underlying structure to determine how the various parts of a linear composition relate to each other. The organization of a painting can be likened to a piece of music, which, in order to stir our feelings, has to be based around well-crafted patterns of musical shapes and interludes. To find these compositional patterns, lay a piece of tracing paper over your image and, starting at the focal feature, trace out the shape that best links this with other elements in the image, either as a triangle, circle or ellipse. The lines should be generalizations and will have to be found by searching. It is easier to look for the larger shapes first. If you turn the image upside down, you will be less likely to be distracted by subject content.

In the painting left, the design of the image is built upon the simple triangular shape formed by the centre line of the figure, the angle of the guitar neck and the top arm of the microphone stand, which I have illustrated in the image overlay. You will also find smaller, secondary triangular motifs, linking other elements within the composition. The purpose of including this image is to show the inherent existence of design motifs. These shapes were not consciously planned, but occurred naturally between the elements.

Adjusting elements

Being aware of design motifs will enable you to adjust points in a composition that might appear awkward or out of place. Moving these elements so that they relate to one or more of the underlying shapes can provide greater uniformity, making a composition easier on the eye (although this should not be forced or contrived). The painting opposite top illustrates the use of design motifs when combining subject matter from different sources. I began to set out this composition without the three right-hand figures and with the intention of making the left-hand sunshade and standing artist my focal elements, but I soon realized that the composition lacked impact. I introduced the three figures on the right from a separate source, to give a more dominant focus.

These figures work together as a single unit because their curved outer forms are contained within a circular motif (shown as 'A' on the overlay), while their three heads are linked in a triangle ('B'). I redrew the composition, choosing the dark standing figure as my focal feature, which I placed on a focal axis line. I then adjusted the remaining elements to fit around this, placing them where I felt they looked balanced. Notice the large elliptical shape, 'C', which visually ties in the curved top of the sunshade and figure in the middle distance, and the additional triangular motif 'D', which links the focal figures and the horizontal ground line. I have also shown one or two additional supporting motifs to illustrate how other elements are tied together. Similarly, in the painting below left, an elliptical motif ties in the curved forms of the boats, while larger, powerful triangular shapes link together other elements in the image.

Overlay showing the major and secondary design motifs

Boat Yard

28 x 38cm (11 x 15in) on 400gsm Not surface Saunders paper
Being aware of design motifs offers you a useful checking mechanism when setting out a composition. In this image, both ellipses and triangles combine to tie in elements in the overall image

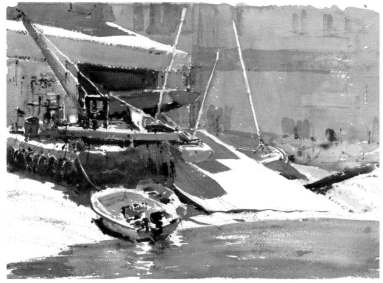

Painters in Montmartre

28 x 38cm (11 x 15in) on 300gsm Rough surface Fabriano paper
Design motifs can be a useful checking mechanism when setting out a composition. In this image, the three focal figures came from a separate source. I placed them where I felt they looked right in relation to the remaining features. Then I slightly adjusted one or two areas in the initial image, in relation to the design motifs, to create a more harmonious composition

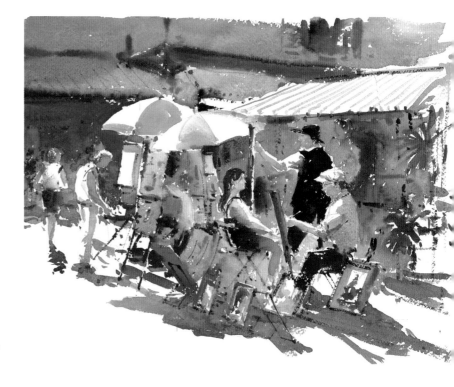

Overlay showing the major design motifs

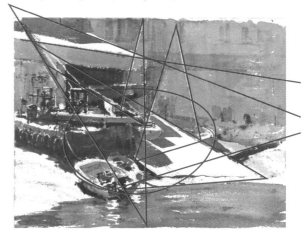

Adding Movement with Figures

Figures are one of the most effective ways of generating a sense of movement and vitality in paintings. Whether they are used as the central point of interest, or in a more supportive role, as a way of depicting scale, or to simply add to the story of an image, they will add humanity to a painting.

Figure doodles

The inclusion of figures can easily ruin otherwise successful paintings, particularly if they appear overworked, or when they look like cardboard cutouts placed in as an afterthought. Although it may seem an obvious statement, figures need to relate to their surroundings in order to appear convincing. Where they occur – in the foreground, middle distance or background – will dictate to a large extent how they need to be portrayed. Clearly, more prominent foreground figures will differ in the amount of information you need to include compared to those in the background. The painting right shows an effective method of painting distant figures as brush 'doodles' – simplified, silhouetted shapes drawn in quickly using a few sweeps of the brush to suggest the general figure form. The process works best when you adopt an almost absent-minded approach and just make marks, applying the paint in the most direct way that you can. Although this suggestion may at first seem rather nonsensical, it is a good way of getting around the notion that figures are particularly difficult to paint and so need to be painted with meticulous detail in order to appear authentic.

In the accompanying worked examples, below, I have demonstrated the process; the best way is to practise painting them first. Incidental figures can be located in this way, either laid in individually, or massed together in groups. The more you are able to observe and draw figures from life, the greater will be your potential for invention, so it is well worth spending time learning how to depict them more effectively.

Figure Doodles
5 x 9cm (2 x 3½in) on 300gsm Rough surface Saunders paper
Don't make your figures bigger than 4–5cm (1½–2in) and for the best results, work quickly, without making the medium too watery

1 Begin by placing in a blob for the head. Don't try to paint a figure; just make marks, which will then take on the appearance of a figure shape.

2 Use the heel of the brush to paint a broader shape for the body, dragging it in a sideways and downwards movement across the paper.

3 Finally, flick in a couple of lines for the legs with the tip of the brush. This shape perhaps suggests a female figure with a coat over her shoulder.

Depicting scale

Figures are an effective means of providing a sense of scale, from which the viewer can immediately determine the size of other elements, or the division of space within a picture. They could be thought of as the visual equivalent to the scale of a map, giving us proportional reference points. In the background, or far-middle distance, figures can be laid in as a broad mass, as in the example of the brush 'doodles'. Figures in the middle, or near distance, may need to be more refined. The key is to try to catch a sense of their underlying gesture without resorting to unnecessary detail, so that they remain in a supporting role and don't detract from the focal features.

In the painting right, the figures give the viewer an immediate clue to the size of the buildings. Although the nearer figures are more complete compared to those in the distance, they remain fairly understated. Notice that the diminishing sizes of the figures creates a feeling of recession. Where you are using supporting figures in this way, faces, hands and feet are unnecessary details. For authenticity, refer to your stock of sketchbook drawings or photographic references for potential figure images.

St. Alban Street
38 x 28cm (15 x 11in) on 300gsm Rough surface Fabriano paper
In paintings where the figures are more dominant, still aim to simplify their forms, as this will create surface movement. Notice how I have simply suggested the shapes of two of the three foreground figures here by painting parts of them negatively

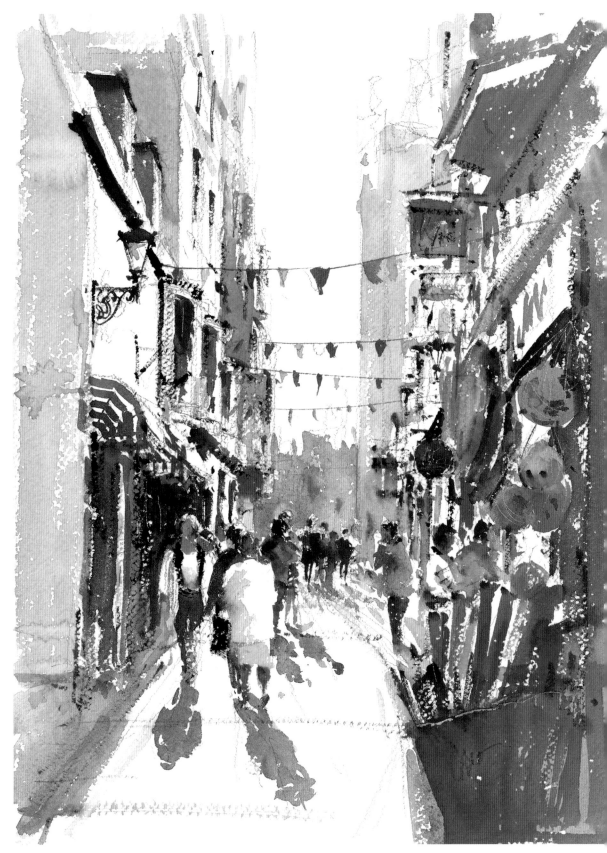

Whenever you have the opportunity, you should sketch figures from life. This will considerably extend your visual vocabulary and increase your ability to render them with confidence.

Telling a story

Through our body language we continuously give out information about ourselves to the world around us. If your figures can capture the essence of this underlying characteristic, even when portrayed with only the briefest of brush marks, they will always appear more lifelike. Before including figures, consider how they might help to add to the story or theme of a painting. This may mean that, even though they are used in a supporting role and are relatively small in size, they need to be portrayed with authenticity. Even the general characteristics of figures in the street can differ considerably from one to another,

so to appear realistic your figures will need to demonstrate a particular locational gesture. In the painting below, the figures tell the story of the painting through their gestural interaction. Although I wanted them to look realistic, I set them into the middle distance so that they would read as part of the general street scene, and I painted them in a loose, understated manner to keep them looking fresh. Painting them in detail would have reduced their energy and vitality. I also played down the more general background figures, laying them in as brush doodles to reduce their impact.

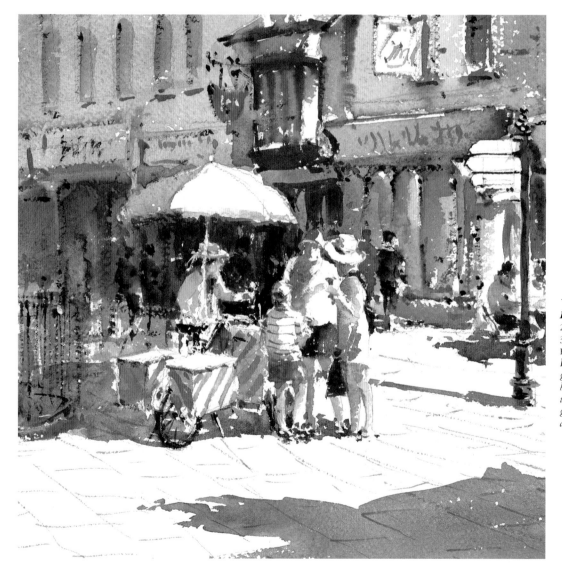

Ice Cream Seller
24 x 27cm (9½ x 10½in) on
300gsm Rough surface
Fabriano paper
Figures need only show a gesture to be convincing. Here I have achieved this with loosely understated brushwork, which gives the figures greater impact and keeps them vibrant

Focal figures

Where figures are used in the foreground, as the central point of interest, they will be larger and will therefore need to be rendered with a greater understanding of proportion. This is in order to depict more accurately the relationships between the various parts of the body (as previously dealt with in Chapter 3). This does not mean having to paint them in meticulous detail; the solution lies in describing their forms with only sufficient information so as to make them understandable. Try not to become discouraged if at first your figures appear laboured or unnatural. To avoid the appearance of lifelessness, or rigidity, in which figures look as if they are made of wood, you will need to show how each part of the figure blends in rhythmic movement with the rest. Always remember that understating the forms creates surface movement and adds vitality to a painting. The solution is to combine precise drawing with directly applied, unlaboured expressive brushwork. In the painting below, I built up the composition from three separate photographic references, adjusting the positions of the individual figures until I found a balanced arrangement, to make the group read as a unified whole. I selected the left-hand standing figure to be the focus. I left out and softened some edges of the forms in places, to allow the eye to move out into the adjoining figures, which I painted in a slightly more impressionistic manner. Because the figure group consists of an odd number, the more isolated standing figure on the right still appears to be part of the group. Where elements are grouped in even numbers, our natural inclination is to see them separated into two parts. Notice how the degree of separation of the isolated figure in the image opposite appears to be more pronounced because it is contained in an even-numbered group.

Rainy Day in St Mark's
38 x 28cm (15 x 11in) on 300gsm Rough surface Fabriano paper
Compared to the previous example, the locational gesture of the figures in this painting tell a completely different story, but are essential in portraying the atmosphere of the place

River Boat Jazz Band
28 x 38cm (11 x 15in) on 300gsm Rough surface Fabriano paper
Where figures are the focal feature in a painting, rhythm and movement will be generated if you can link some of the forms by blending their edges, or in some places leaving out edges completely

Combining Source Material

When painting away from the subject, there is the added advantage of being able to create images from a variety of sources. These could include combinations of 'on the spot' drawings, photographs, memory, or imagination. This allows us to be inventive and create more personal interpretations of our subjects.

Strong horizontal and vertical forms

Pleasing shapes

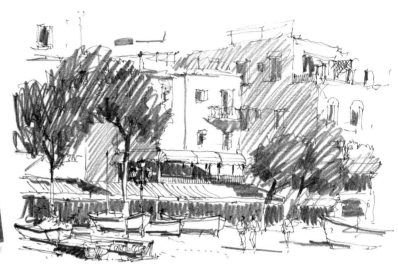

Positano
28 x 38cm (11 x 15in) felt-tip pen and pencil sketchbook drawing. The original photograph is shown left, the basis for the eventual combination

Combining material

The photograph above shows an area of the foreshore at Positano in Italy, which I felt contained some visually interesting features. I was particularly attracted to the jumble of boat shapes and the way the row of canopies on the buildings created a dominant horizontal form, broken at intervals by the contrasting vertical tree trunks. I took this picture in support of an 'on the spot' drawing. Compared to photographs, 'on the spot' drawings will always be more selective in content. Although this image offered considerable potential as the basis for a studio painting, it contained too much information and, more importantly, it lacked a definite central point of interest. I felt the subject could be substantially improved with the inclusion of a dominant foreground feature, together with a general reduction in its content. Having looked through my sketchbooks for something suitable, I decided to try adapting the sailing boats from the photograph right. Although taken from a completely different location, I felt they might work in this image.

plus ...

Powerful shapes

Sailing boats: photograph
The source of the additional foreground feature

Develop a composition

I began to design a composition by making some small preliminary pencil sketch layouts, 13 x 19cm (5 x 7½in) in size. I set out the dominant features in relation to compositional balance points and focal axis lines, as described earlier in this chapter. In the first sketch, I included a single boat, setting the vertical line of its sail one-third of the way in from the left-hand side of the image. I placed the dominant front edge of the row of canopies on the buildings on a horizontal focal axis line, dividing the image in the ratio of 5 to 8, as shown. In the second sketch, to make the focal feature appear more interesting, I increased the number of sailing boats, keeping them in odd numbers so they would still read as a single entity. As a variation, I produced a third sketch moving the focal sailing boats over to the right and slightly altering their arrangement. I tended to favour this layout because the group of boats now formed a prominent triangular shape motif (shown on the sketch with hatched lines). This effectively held them together and helped to generate movement across the image. I also moved the three background trees closer together, so they would read as a single shape, in an attempt to further simplify the overall design.

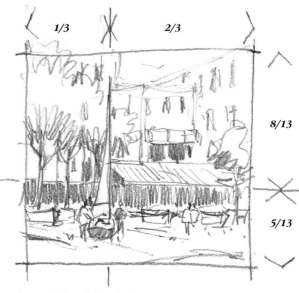

Compositional Sketch 1
Setting out dominant horizontal and vertical features on focal axis lines gives a composition a balanced underlying structure

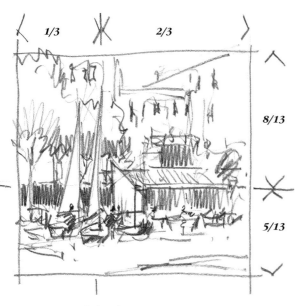

Compositional Sketch 2
Good design is about everything working together; until this happens, nothing should be thought of as fixed

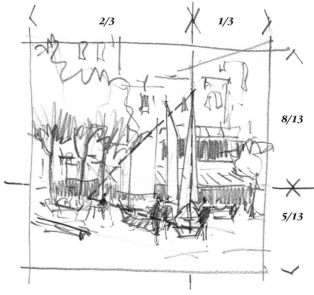

Compositional Sketch 3
Drawing on a tracing paper overlay is a useful way of designing a composition. It allows you to locate elements by adjusting the overlay over the top of what you have done previously, to see what works best

Although the linear design sets out the basic structure of an image, before starting a painting you should consider how you might use other design pointers to help direct the viewers' eye to the focal features. This will help you to continue to see the painting as a unified whole.

Design the tonal pattern

Having decided to proceed with my third compositional layout, I moved on to trying out alternative lighting arrangements, so I could set the overall tonal pattern of the image. I also wanted to be certain that I was maximizing the full tonal potential as a visual indicator in directing the eye towards the group of sailing boats, my central point of interest. I produced three tonal roughs, using Lamp Black watercolour at 20 x 30cm (8 x 12in), working on cartridge paper photocopies of my chosen layout drawing for convenience.

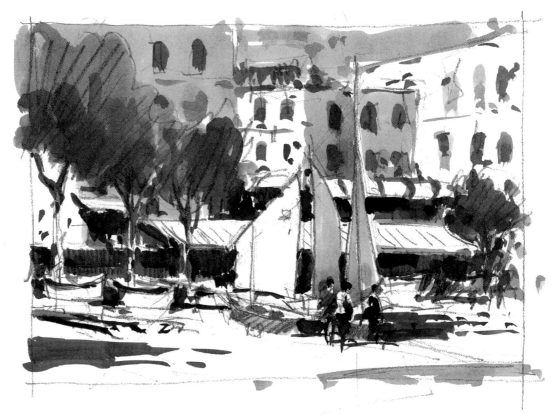

Tonal rough 1

For this image, I set the lighting direction coming from the left. I began at the focal features, leaving the left-hand boat sail as white paper, as if it were catching the full light. To exaggerate this effect, I laid in some contrasting dark tones next to it in the background buildings, keeping my edges hard to give it more impact. The remaining boat sails were at an oblique angle to the light, so I painted them slightly darker. I then blocked in the intermediate values in the background buildings, leaving white paper for the canopies and the building façades that faced the light.

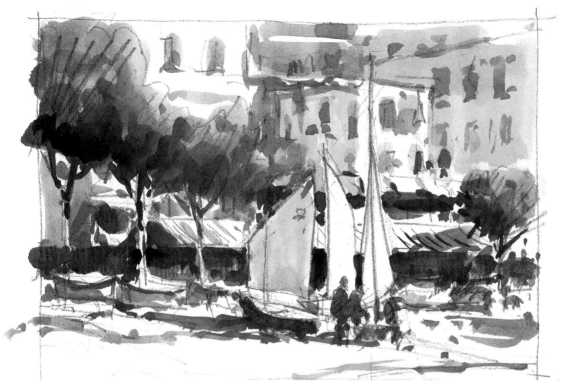

Tonal rough 2

In this image, I set the lighting in the opposite direction, coming from the right and from slightly behind the viewer. My approach was the same as in the first image, but now the focal boat sails were reversed in value. Again, tonal contrasts and hard edges reinforced the impact of these features. Compared to the first example, the dominant light sails now lay exactly on a vertical focal axis line.

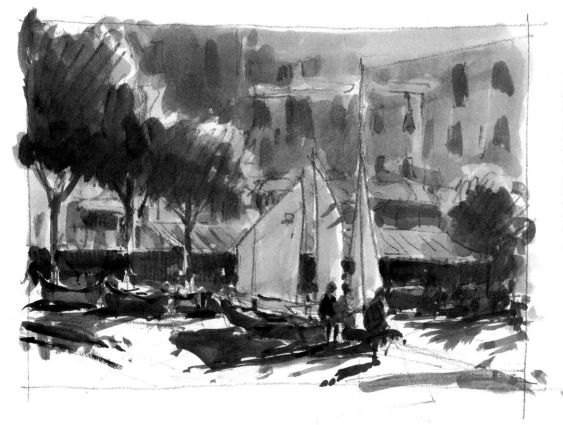

Tonal rough 3

For this image I again placed the lighting direction to the right, but this time coming from slightly in front of the viewer. Although this generated more dynamic ground shadows, it also changed the whole tonal arrangement, mostly in the background buildings, which now appeared to all be in shade and were virtually the same mid-toned value. In the next chapter in the book, I explore more fully how best to plan and use the effects of light.

Although thinking through major design considerations early on will allow you to begin a painting on a more certain footing, rhythm and movement are further factors to bear in mind during the painting process itself.

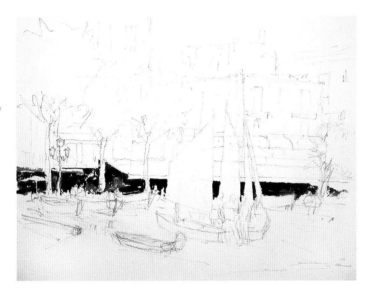

Beginning the painting

Basing my painting on tonal sketch 2, with the light coming from the right, I drew out my final composition in 4B pencil on watercolour paper. I included an extra group of three focal figures to give the image additional movement and to provide a sense of scale. I began by laying in the shape of the dark horizontal band under the canopies using mixtures of Light Red, Indigo and Raw Sienna.

Work around the image

Try to keep the whole painting moving along at the same time, rather than completing elements in isolation. I worked around this image, first painting the shaded boat sail with a mixture of Raw Sienna and Alizarin Crimson, then the background boats with Neutral Tint and touches of Cerulean Blue, then moving on to the warmer background buildings, using mixtures of Raw Sienna greyed down with Cobalt Violet.

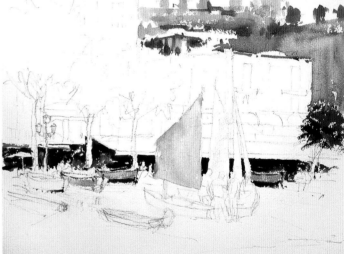

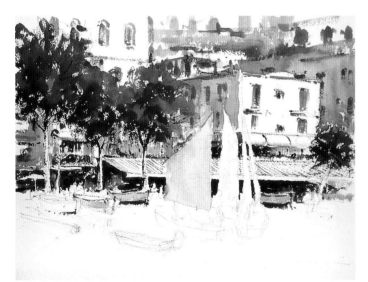

Establish the main forms

I continued building up the main forms, working across the background. I placed in the trees as a single mass, using rich greens made from Cadmium Lemon, Prussian Blue and Burnt Sienna. I laid in the original colour of the buildings between and around them while they were still wet, carefully cutting around the shapes of the white sails and finally drawing in suggestions of the windows.

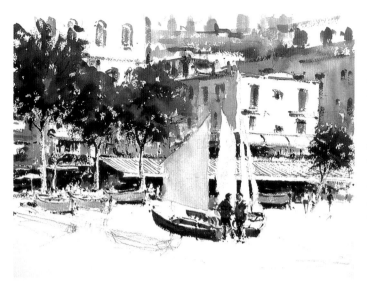

Keep the focus understated

Although here I kept the focal figures understated, I also used value and colour indicators to increase the feeling of movement and draw the eye towards them. I painted them dark against the white sails and used pure touches of Ultramarine Blue and Light Red to make them stand out. I also used a rich mix of Alizarin Crimson and Raw Sienna for the darker boat.

Finished painting

I included the additional foreground boat and added directional shadows on the ground and canopies. To further highlight the focal elements, I painted one boat sail with pure Cadmium Lemon and a lighter, discordant touch of Cobalt Violet. I added the suggestion of a number on each sail to complete the painting.

Sailing Club
30 x 40cm
(12 x 16in) on 300gsm Rough
surface Arches paper

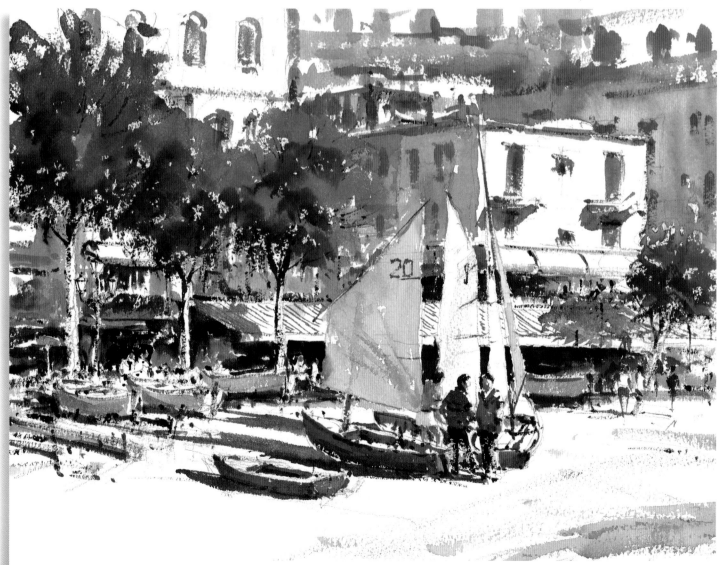

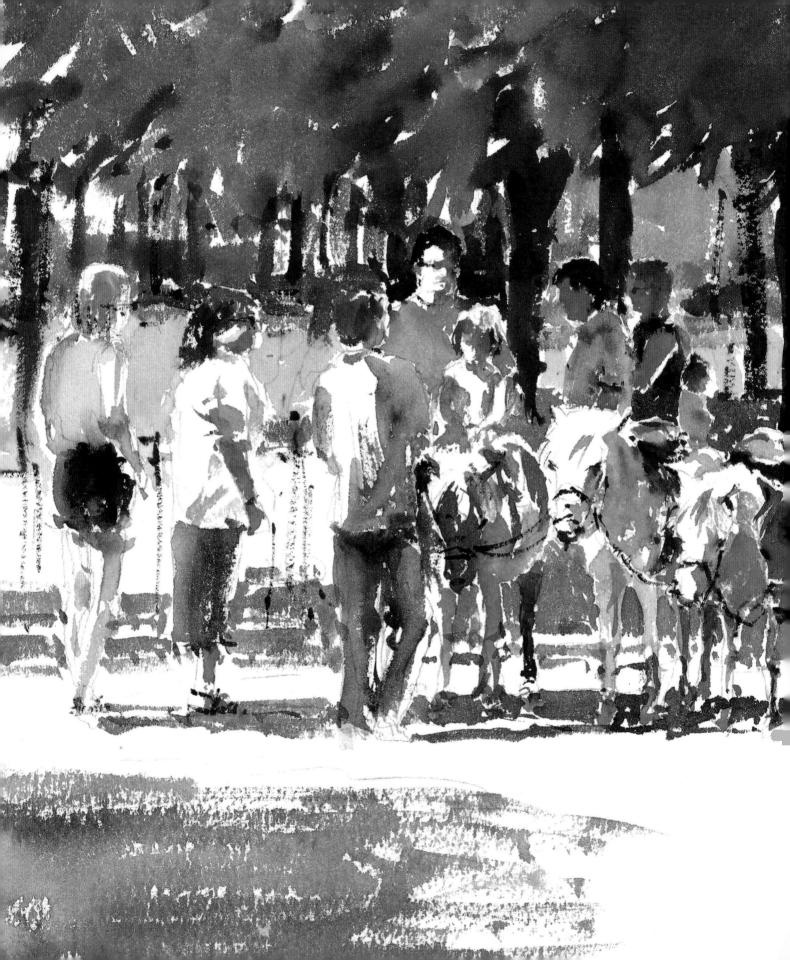

Creating Vitality with Light

Portraying light is one of the most challenging, yet rewarding, aims for the watercolour painter. Since light in paintings is only an illusion, to do this convincingly, we must learn the means of conveying the effects of light, in order to fool the brain into perceiving the level and intensity of lighting. This can then lead us towards producing paintings that reach out beyond the medium itself.

Donkey Rides in the Luxembourg Gardens
30 x 40cm (12 x 16in) on 300gsm Rough surface
Arches paper

Planning the Light

L ight in paintings is achieved principally by controlling the distribution of tonal values (lights and darks) rather than from the colours used. To prove this, change colour television pictures into black and white and you will see that the lack of colour makes no difference to your ability to see things as they are.

Designing the lighting pattern

Light defines three-dimensional form and volume, enabling us to distinguish separate shapes in relation to space, distance and atmosphere. The depiction of light is crucial if we are to create paintings that are fresh and exciting. Lighting direction can also be manipulated to intensify a subject and will create different pictorial opportunities, so it is well worth exploring alternative lighting patterns as a prelude to producing studio paintings. Decide first where the more dominant focal areas of maximum tonal contrast are going to be and then adjust the remaining middle range supporting values around them.

Interior, Villa Balbi
37 x 33cm (14½ x 13in) on 640gsm Rough surface Arches paper
Often the pattern of light can be used to enliven a painting. Here the powerful descriptive shapes, created by the intensity of the light from the outside, gave this interior additional excitement. To depict the illusion of light, it is best to fix the tonal lighting pattern for the whole image before you start

Lighting study 1

In this example, I placed the light source behind the viewer, coming slightly from the right. I broke the subject down into large masses and defined these shapes in a simplified range of five tones (as previously described in Chapter 4). From this lighting direction, the three front-facing walls of the buildings would receive direct light, so I made these my lightest lights by lifting them to white paper – tonal value 1. To define the intensity of bright sunlight, I painted the darker openings in the walls black, as my darkest dark – tonal value 5. I set the pattern of the remaining elements in a range of intermediate tones, subordinating the less important features in the middle distance and background. The roof areas and roadway, which would receive only glancing light, I placed in as tonal value 2, together with the distant background hill. I painted the darker-shaded walls and foreshortened roof to the front building as tonal value 4, leaving an area of the hill above the building as tonal value 3. I placed the remaining foreground elements in as a mixture of tones.

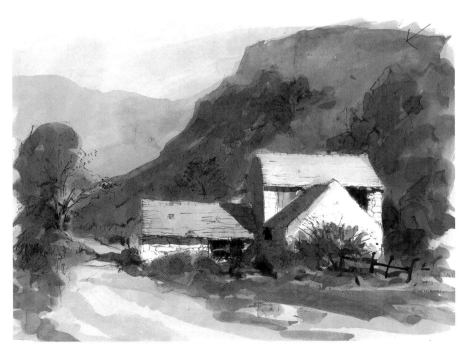

Barns near Abertrinant, Lighting study 1
29 x 42cm (11½ x 16½in) on cartridge paper
I used Lamp Black watercolour for this study, breaking the subject down into a reduced range of tones

Looking against the light

When looking into the light (often referred to as contre-jour lighting), the intermediate or middle-range tonal values become absorbed into the darks. This is because objects are now seen in shade, making them appear more like silhouettes. Any points or planes that do catch the full intensity of the direct light will appear much brighter, owing to the difference in tonal contrasts between the planes.

Lighting study 2

Changes in lighting direction can completely alter the dynamics of a painting. Compared to the first lighting study, here I changed the lighting direction to be in front of the viewer, as if looking into the light. Generally all the forms are now in the shade, so I painted them at about the same tonal value as the shaded areas in the first example (tonal value 4). Only the road, the foreshortened roof, the ridges of the long buildings and one or two places on the top of the tree and fence posts will be seen to catch the direct light. I placed these in as my lightest lights, leaving them as white paper, or adding back the smaller points of light with white gouache. As in the first study, the door openings in the buildings are still strong darks, but their intensity has been reduced by the proximity of the now darker values of the shaded elements around them. Most of the foreground and middle distance forms have also been lost in this image.

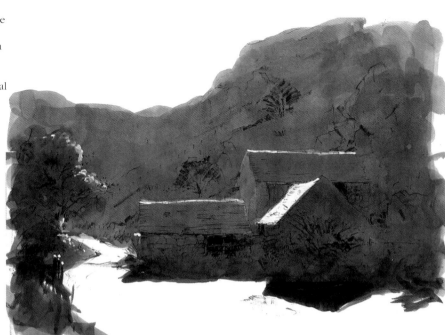

Barns near Abertrinant, Lighting study 2
Contre-jour lighting reduces the range of tones by pulling the middle values towards the darks while retaining the lightest lights, thus appearing to exaggerate the intensity of the light

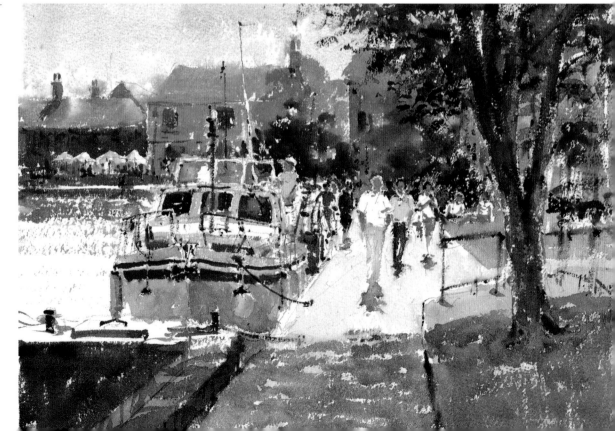

Riverside Walk
30 x 40cm (12 x 16in) on 300gsm
Rough surface Arches paper
Often the attraction of a subject can be the light itself. Here, the intensity of the contre-jour lighting has been increased by the shadowed foreground area and generally darker-toned background forms

The Potency of Shadows

Shadows are an integral feature in depicting the illusion of light. Their shapes and patterns provide visual clues to the direction and intensity of the light, and their lively treatment can increase both the energy and vitality in paintings.

Shadow direction

When painting outside from nature, it is easy to fail to notice how shadows are constantly changing in relation to the very slow movement of the sun. It is always best, therefore, to draw them all in together at the start, even though the light may have changed when you come to paint them. This will prevent the risk of producing paintings in which the lighting appears to come from several directions at once. Generally, you will have about an hour and a half before the light begins to seriously disrupt the tonal relationships within your subject. At this point you may have to stop and return again at the same time on a different day, or begin another painting based on the altered lighting pattern. A worthwhile idea is to limit the size and complexity of a painting to something you can expect to complete within this amount of time. Also, painting the same subject from the same spot at different times of the day will make you aware of the influence that shadow patterns can have.

Shadow edges

The key to painting realistic-looking shadows lies in making them appear to melt into whatever surface they fall across, so that they don't ever look like solid objects. To do this, keep their edges soft; that is, never place a solid line around them. I am not suggesting that shadow edges need to be blurred or blended into adjoining areas – they obviously have definite boundaries, particularly in strong sunlight – only that they must never have a linear edge, or the illusion will be lost. Generally, the brighter the light, the darker the shaded surfaces and cast shadows will be. Try not to see shadows as separate elements but as a continuation of the objects from which they are cast. Then paint the object and shadow as a single form, varying your colours as necessary as you proceed, as in the painting opposite top.

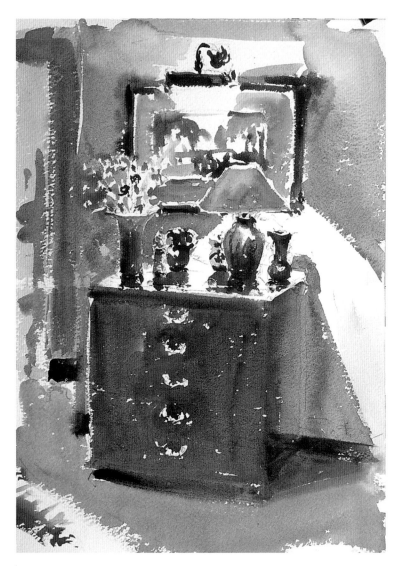

The Table Lamp
40 x 29cm (16 x 11½in) on 300gsm
Rough surface Saunders paper
Often light can have the effect of making ordinary, everyday things appear more interesting. In this image, the shadow patterns are fundamental to creating the illusion of concentrated intense light, characterized by their definite edges. The reflections of the objects in the brightly lit surface add to the overall effect

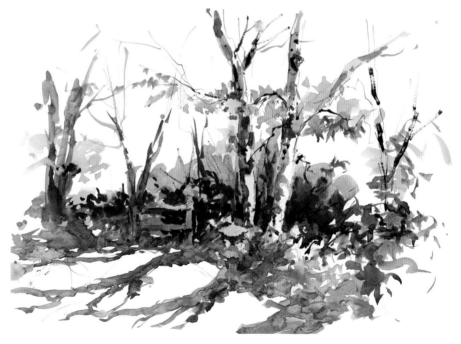

Harley
20 x 28cm (8 x 11in) on 300gsm Hot pressed Fabriano paper
*Linking the forms of object and shadow can considerably
simplify an image. Here I ran the forms of the bike wheels and
ground shadow together, without defining a boundary. I then
redefined the front wheel to make it slightly more dominant*

Shadow colour

Shadows can be painted in any colour, provided
their relative tonal values are correct. A useful
guide for determining shadow colour is that
they will lean towards the nearest lower (cooler)
colour on the colour wheel of the surface onto
which they fall. For example, a shadow falling
across an orange surface will tend towards a
darker, cooler, reddish violet. A shadow cast
onto a green surface will edge towards a darker,
cooler, greeny-blue. Although this might point
you in the right direction, it is not a prescription
for success, so always be guided by what you
see. Combining different colours in shadows
gives the impression of reflected light and will
keep them looking lively. The secret to painting
convincing shadows lies in making them appear
transparent. This does not mean that the colours
used have to be transparent, only that you have
to create the *illusion* of transparency. So avoid
painting flat, lifeless shadows in muddy browns,
or dirty neutrals, which are more often the
result of overmixing. Also, it will
help to create the feeling of warm light if
shadows are painted cooler in temperature
than their surroundings.

Summer Trees
29 x 40cm (11½ x 16in) sketchbook study
*To understand the influential effect of shadows, make some sketchbook studies on a sunny day to
record the relationship between subject forms and shadow shapes. I kept the shadows looking fresh
in this image by painting them in rich colours. Notice also how the angle of the shadows describes the
slope of the foreground*

Building Lighting Effects

Light is essential in the creation of mood and atmosphere. Although light defines form in relation to three-dimensional space, understanding how different levels of illumination can affect form is vital for creating a variety of lighting effects.

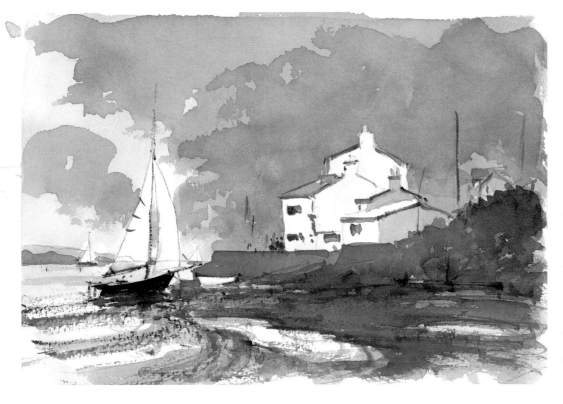

Normal lighting

In conditions of normal daylight, a full range of tonal values will be generated, from white through to black, with all other values in between. There will also be maximum tonal contrasts of white against black, making objects appear clear and well-defined, together with the creation of crisp shadow shapes. In colour, this effect would be depicted with bright, clear hues.

Light and form

To convincingly portray the effects of light, we need to be aware, in the first instance, of how light alters the relationships between tonal values (lights and darks) under different lighting conditions.

Knowing how to control and manipulate these characteristics is essential in creating a sense of mood. To illustrate this, I have included three tonal paintings of the same subject in which I have illustrated three alternative levels of lighting intensity: normal, dim and misty. I produced each image using Lamp Black watercolour at 17 x 26cm (7 x 10in), and my aim was to try to make the lighting effect transcend the medium. Making small monochrome studies, like the examples here, will help you to fully appreciate the theory. Unless you are able to produce the effects of light in monochrome first of all, you will be far less likely to do so when working in colour. When painting these studies, the full impression of the lighting will not become fully apparent until all the paper has been covered.

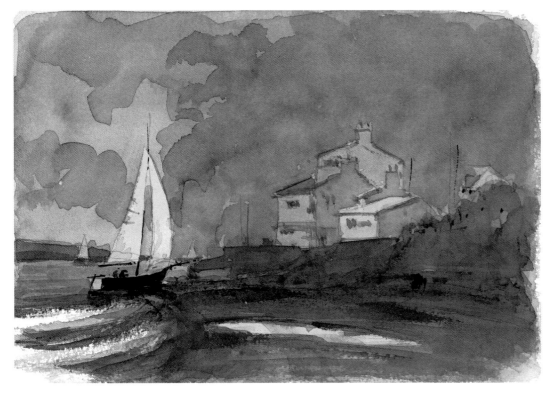

Dim lighting

As the level of lighting diminishes, so the general tonal distribution will gradually move progressively towards a darker grey scale, resulting in all deep values blending together. Black will be maintained, with the lightest light (white) moving down towards the adjacent lower value on the tone scale. Where there is very little light, as at night, for example, forms will become more silhouetted, or lost altogether, as the level of illumination becomes further reduced. To convey these effects in colour, hues would have to be blackish and muted.

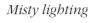

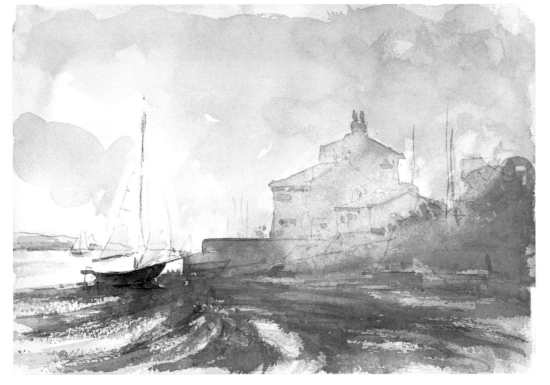

Misty lighting

To depict the conditions of misty light, tonal values need to be adjusted towards a middle value, so that an overall image will appear to be generally light grey, with the blacks and dark greys becoming lighter when compared to dim illumination. Thus the overall span of values will be reduced to a scale of white to mid-grey, rather than extending through to black. Here colours would generally be more neutral and greyish in character.

Colour relationships are affected by changes in illumination levels in a similar way to tonal values. While the lightness and darkness of colours follows a particular tonal lighting pattern, to enhance the atmospheric lighting effects in colour we have to be able to manipulate subtle variations in colour temperature and intensity.

Light in colour

I have included three images to show colour examples of the normal, dim and misty lighting levels, as dealt with on pages 96–97. My intention was to make the lighting quality the dominant feature in each painting. I first made a tonal rough for each image, similar to the previous examples, to fix the tonal lighting pattern. I then matched the lightness and darkness of my chosen colour mixes to the tonal roughs in each case.

Riverside Moorings
30 x 40cm (12 x 16in) on 300gsm Rough surface Arches paper
Selecting rich, bright colours will add a feeling of joyousness to the lighting quality of a painting

Normal lighting

To increase the illusion of a bright sunlit day, I used clear, sharp colours for this painting, matching them to the actual colours in the subject. The intensity of the light generated distinct contrasts and powerful directional shadow shapes, within a full range of tonal values. I used combinations of primary colours: pure Ultramarine Blue for the clear sky, and mixtures of Cadmium Lemon, Burnt Sienna and Prussian Blue for the bright green tree foliage. I kept the shadows alive by blending Ultramarine Blue, Burnt Sienna and Cadmium Orange, and I used contrasting values of Indigo, Light Red and Raw Sienna for the local colours on the boats. The touch of Alizarin Crimson on the focal figure served as a colour pointer to further attract the eye.

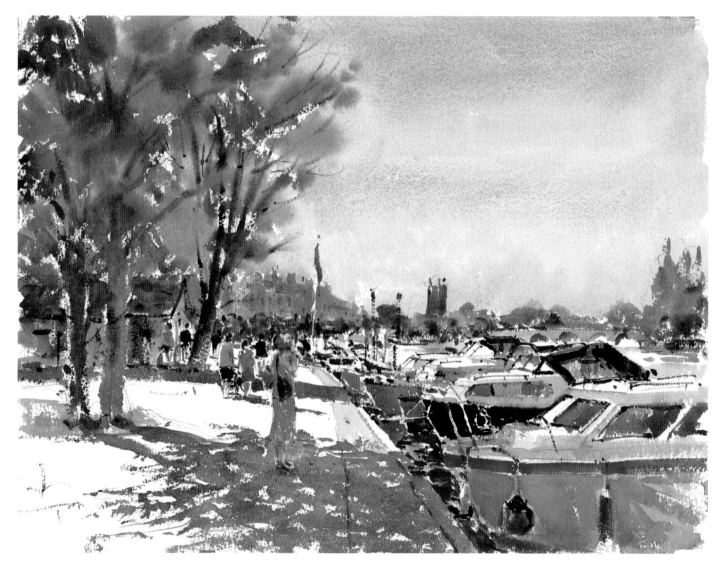

Dim lighting

Compared to the lighting quality shown in the previous example and in the painting of a similar subject on page 66, this image is more subdued, with the majority of colours being blackish or in the lower tonal range. In depicting the low level of lighting, it was essential to also keep the dark colours alive, so rather than using a tube black or grey, I mixed a near-black from Alizarin Crimson, Viridian and a touch of Burnt Sienna. For added variety, each time I picked up more colour, I alternated between adding in a touch more red and green, to warm and cool the mix as I went along. I introduced Raw Sienna for the lighter building façades. The lightest lights on the buildings are areas of white paper, while the lights on the water I added back with white gouache. My aim was to keep the entire painting understated, so that the dominant effect of the lighting would not become diluted by unnecessary elaboration.

Venetian Canal
38 x 28cm (15 x 11in) on 300gsm
Rough surface Fabriano paper
Keeping dark colours alive and minimizing overpainting are the keys to painting dim lighting. Darks should be colours, not collections of dull browns or dirty greys

Misty lighting

This painting is an example of how colour can be used to increase the atmosphere of misty lighting. To emphasize the generally middle-value grey lighting quality, I selected a range of colours that I felt would create neutral mixes and therefore be gentler on the eye. I used predominantly secondary colours: orange (Cadmium Orange), violet (Cobalt Violet) and green (made by mixing Raw Sienna and Lamp Black). This enabled me to produce a more subdued range of greyish neutrals.

Compared to the two previous examples, this painting contains no red or blue, and the yellow used (Raw Sienna), being an earth colour, is itself fairly subdued. Although the colour here may appear to simply tint the image, its power lies in the subtly restful and calming effect it brings to the lighting.

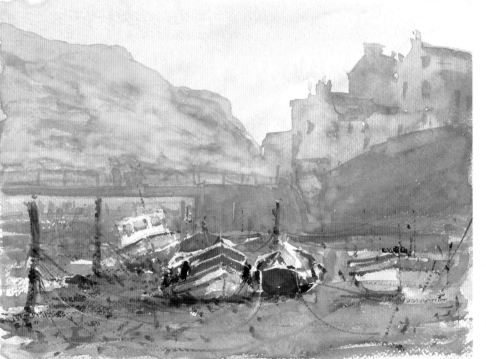

Low Tide
28 x 38cm (11 x 15in) on 300gsm Rough surface
Fabriano paper
Spectral greys are naturally quieter and add to the serenity of a subject

Intensifying Mood

Mood in paintings can affect us in many ways, by arousing feelings such as joy and excitement, or alternatively peace and tranquillity. These are elusive emotional qualities through which images can be transformed into something more than just the painted marks on paper, and here colour is the catalyst.

Harbour Moorings
28 x 38cm (11 x 15in) on 300gsm Rough surface Fabriano paper
My aim here was to catch the mood of strong sunlight across the row of brightly coloured boats. Working with a selection of primary colours, I played down the importance of the sun-drenched background buildings by leaving them, more or less, as white paper

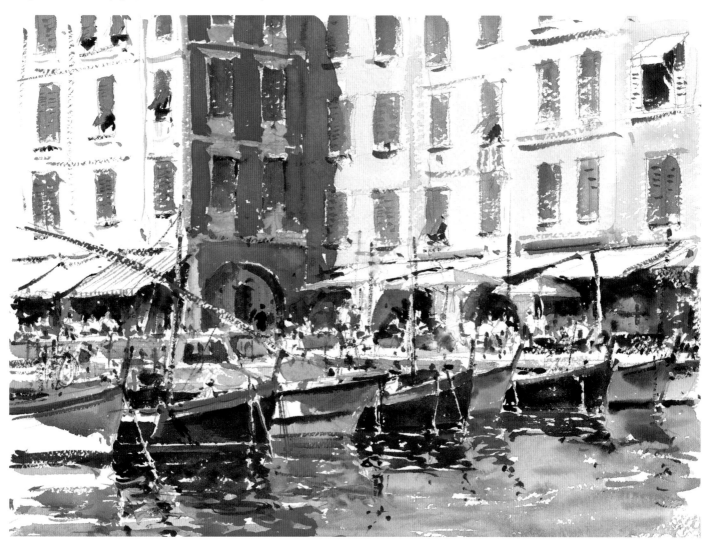

Mood and colour

Although light and shade is the primary determinant for the creation of mood, colour and mood are virtually inseparable. Even everyday language contains expressions that link colour and mood, such as 'seeing red' or 'feeling blue', which we use to express particular emotions. However, creating mood through colour is by no means a foregone conclusion. It is not just about applying certain rules, since what works for one painting may not necessarily work in another. Throughout this book, I have advocated the use of the direct method of painting to bring

out the immediacy of the medium; this in itself creates a general spirit of instinctiveness and spontaneity. When this approach is based on precise lighting arrangements *and* is combined with well-chosen colour combinations, the basic foundations for the creation of mood will have been established. In the painting above, for example, the bright, clear colours of the boats and their reflections intensify the feeling of strong sunlight created by the underlying tonal pattern in the painting.

Chromatic mist

Another way to understand how colour influences mood is to think of looking at the natural world through pieces of different coloured plastic or glass. This has the effect of making an entire subject appear to be saturated with coloured light, or mist. This effect is relatively straightforward to produce in watercolour and some intriguing results can be obtained with a little trial and error. It is best to begin by laying a colour wash over the entire paper. Try blue, pale grey, or a more vivid colour such as bright yellow, pale violet, or magenta. All subsequent colours will be modified by this underlying colour and, provided you restrict your colours and don't overpaint too much, this will give an unusual general colour cast to the whole image. In the painting right, I wanted to get a sense of the early-morning haze over the water, predominant in this location. I laid a diluted colour wash of an intense yellow, Cadmium Lemon, over the entire paper first and limited my remaining colours to Burnt Sienna and Lamp Black.

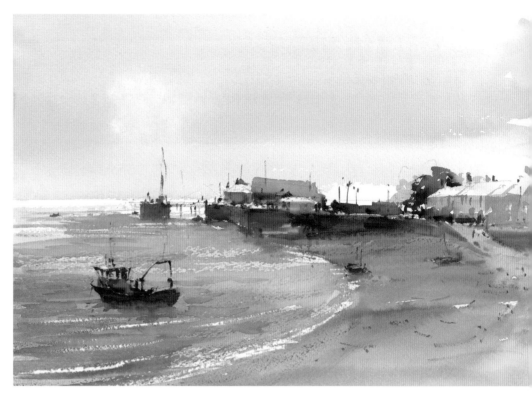

Aberdovey Daybreak
29 x 42cm (11½ x 16½in) on 300gsm Not surface Saunders paper
To create the misty sky, I laid a very diluted layer of Lamp Black over the original wash of Cadmium Lemon, blotting out the patch of hazy sun. Mixing black with yellow usually changes it into green. However, when the black is overlayered separately, as here, the yellow will be neutralized yet still retain its identity

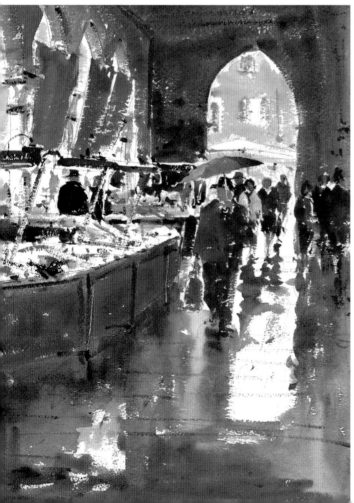

Colour variations in dim light

Colours will become darker and more muted as lighting levels diminish. To prevent paintings looking dull, it is particularly important to guard against darker colour mixes becoming muddy or dirty. In the painting left, I used a limited triad of milder versions of the three primaries (Indigo, Light Red and Raw Sienna) to depict the darker, more muted colours of this interior on a rainy and overcast day. I laid in the darker colours of the walls, ceiling and floor in one go, working around the painting and letting the colours of adjacent areas blend together as I went along, while cutting around the shapes of the lights. I also used the natural fluidity of watercolour to increase the mood of the wet weather.

Fish Market
40 x 30cm (16 x 12in) on 300gsm Rough surface Arches paper
Get used to placing in dark colours at their correct tonal value in one application, instead of darkening areas by overlayering. This will help you to keep even your darkest colour mixes looking fresh

Sculpting out the Lights

The term 'painting the light' actually means painting everything other than the lights; watercolour painting necessitates preserving these areas as the white paper itself. The key to producing light-filled paintings lies in how well you balance these areas against the rest of the painting.

Build a composition

The drawing and photographs shown right and below depict areas of South Beach, Miami, USA. The outdoor cafés, figures and tropical palms present an interesting array of patterns and shapes, making it an ideal subject for painting. My on-site sketch and the photographs showing areas of a pedestrianized mall combined to make a well-balanced composition, which I felt would enable me to create a lively impression of the place. The photographs also give a sense of the bright sunlight that is one of the defining features of the area; I therefore needed to find a lighting arrangement that would enhance these characteristics.

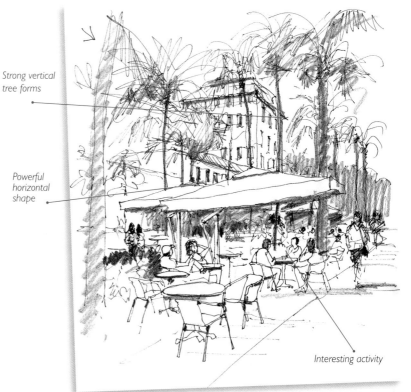

Strong vertical tree forms

Powerful horizontal shape

Interesting activity

Interesting tree shapes

Building façade too bland

Light defined by strong shadows

Confusing background buildings

Active figure groups

Good descriptive ground shadows

Design the lighting pattern

To find your way into a painting, make some preliminary
tonal roughs first to explore the potential of alternative
lighting directions. Although these could be made equally
well in pencil, producing them in watercolour will allow
you to rapidly lay in areas of consistent tone. In the
accompanying examples, I drew out the main elements
of the subject in pencil first and developed each of the
images by building up the shapes of the main lights and
darks, simplifying them into larger masses and reducing
them to just a few values. Often one or two simple tonal
shapes will be enough to convey a quality of light and
thus determine the likely effectiveness of an image.

Light coming from the left

In the first example, I illustrated the lighting direction
coming from the left, as shown in the photograph. This set
the buildings on the right in direct sunlight and placed all
the left-hand features in shadow, except for the tops of the
sunshades, which caught the light.

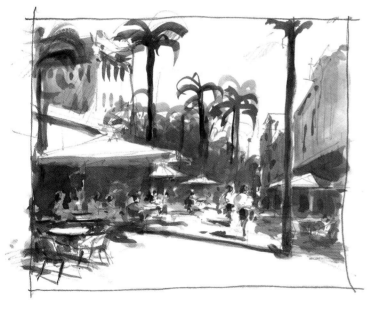

Light coming from the right

In the second study, I moved the lighting
direction over to the right and slightly
behind the viewer. This broke the image
down into a more simplified range of
tonal shapes and gave it greater clarity.
Having the right-hand elements in the
shade also created interesting directional
shadows from the foreground trees,
although the image now appeared to be
lacking a definite focal point.

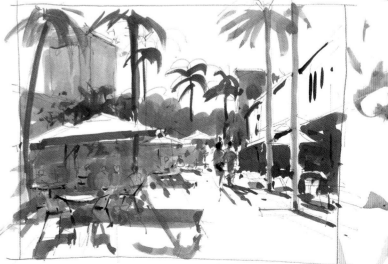

Looking against the light

For the third example, I placed the lighting direction in front of
the viewer, slightly to the left of centre. This altered the whole
pictorial effect and created a simpler, more dynamic pattern of
tonal shapes, with the foreground directional shadows drawing
the eye into the picture. The tonal counterchange between the
upper and lower levels of the buildings on the right, and the toplit
sunshades set against the surrounding darker-shaded areas on the
left, helped to increase the visual intensity of the light. I chose this
tonal model for the subsequent painting because it made the light
a more dominant feature, while also simplifying the overall image.

With the general pattern of lighting resolved at the outset, you can begin a painting on a more certain footing. Knowing exactly which areas of white paper are to be retained as the lightest lights will enable you to concentrate on matching the tonal values of your chosen colours in the rest of the painting to the predetermined values in your tonal model.

Make a layout drawing

I transferred my final composition onto a sheet of 35 × 56cm (14 × 22in) watercolour paper. Notice that I have replaced the rather anonymous foreground figures with a single focal figure, which I took from the second photograph. I felt that this would create more impact, provide additional movement, and add to the story of the place.

Start with some darks

Getting some darks in early on sets the tonal parameters of a painting. After first laying in a pale sky wash of Cerulean Blue, I began to sculpt out the negative shape of the sunshade by painting the adjacent elements, matching their values to my tonal model. I painted the sides with Ultramarine Blue and Indigo, and then placed in the darker background trees, using Cadmium Lemon, Burnt Sienna and Prussian Blue.

Define the main forms

I continued to define the general forms of the background trees, cutting around the shapes of the smaller sunshades and drawing in the taller trees at the same time. I applied wet-into-wet mixtures of Light Red, Indigo and Raw Sienna for the darker ground-level windows in the right-hand buildings, while carefully shaping around the forms of the sunshades, foreground trees and single seated figure.

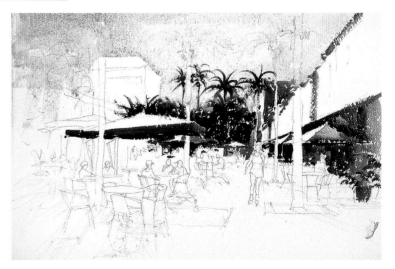

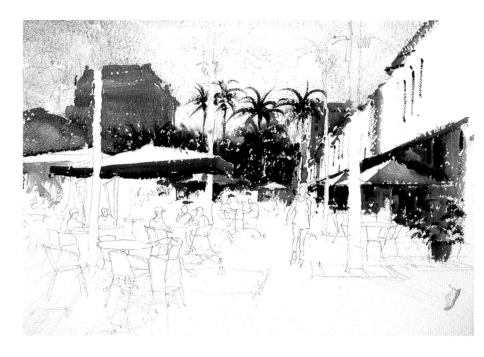

Look out for the turning point

I completed the background forms with the silhouetted shapes of the shaded buildings on the left, using mixtures of the same colours. The painting had now reached a crucial turning point, where the accumulation of initial marks had begun to bring the light in the image to life. The rest of the painting process would now be about adding to what was already there.

Keep your eye on the focus

Parts of a painting can be made to appear less dominant by lowering their tonal contrast. Although I wanted to depict some activity in the left-hand foreground, it was essential that this should not detract from the focal figure. I applied a mid-toned, wet-into-wet, broken wash of Raw Sienna, Burnt Sienna and Ultramarine Blue to this area, again matching the tonal model. The subsequent features would then appear less assertive.

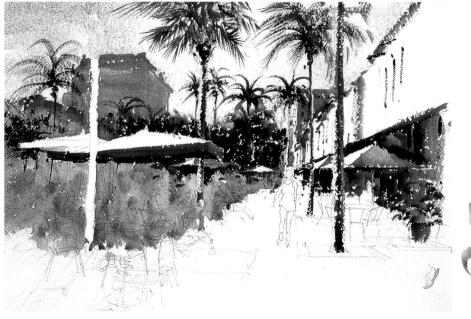

As a painting moves towards completion, the vitality and strength of the lighting can easily become obliterated by excessive overworking and too much detail. It is therefore most important to keep the remaining elements understated to retain the initial sparkle.

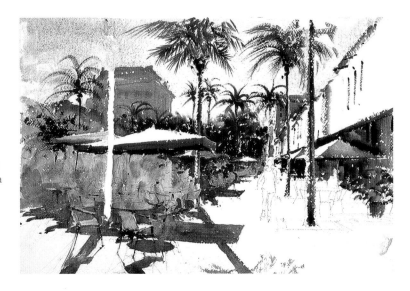

Keep it loose

I carefully painted the descriptive shapes of the left-hand ground shadows, blending Ultramarine Blue, Burnt Sienna and Cadmium Orange to keep them looking lively, while also painting around the negative shapes of the nearer chairs and table. I drew in some of the chair legs with a fine rigger brush as I went along, using a strong dark made from Ultramarine Blue and Burnt Sienna.

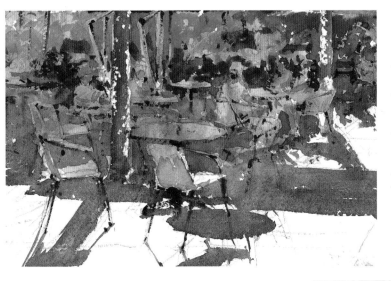

Retain the freshness

It is essential to keep overpainted areas looking fresh. This close-up of the left-hand foreground shows my use of direct, unlaboured brushwork to suggest the remaining negative shapes of the seated figures, tables and chairs under the sunshades. The initial mid-toned underpainting has reduced the dominance of these elements. These now show through as broken areas of colour, which keeps them looking lively.

Preserve the simplicity

In this close-up of the right-hand café tables, I played down the forms by painting just their shaded surfaces. I merely hinted at the figure, tables and one or two of the chair legs – this was just enough to suggest what they were. The shape and direction of the ground shadow gives meaning by creating the feeling of light across these forms, while holding them all together.

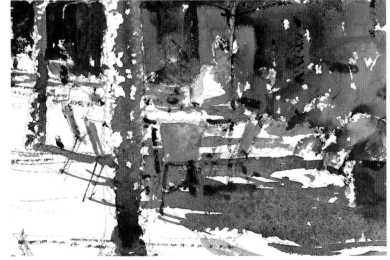

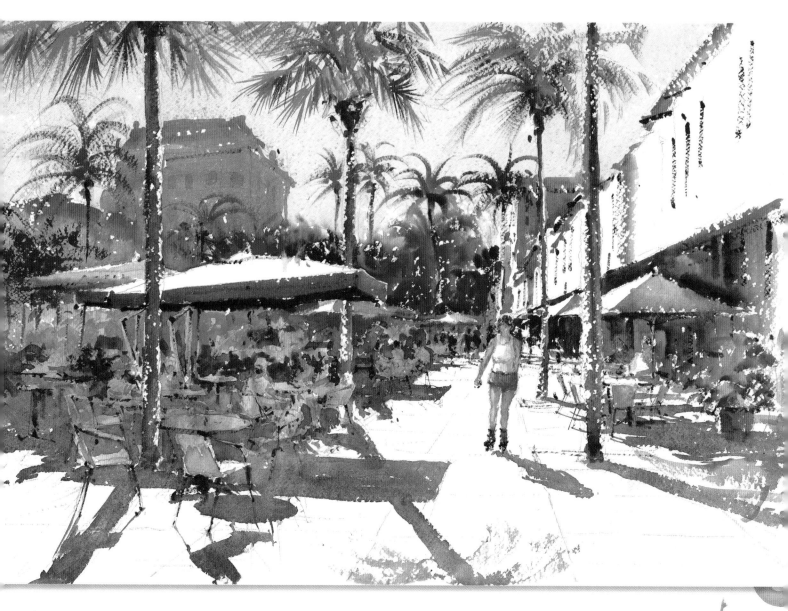

Finished painting

To complete the painting, I added the focal figure as a more dominant, hard-edged shape. I increased its impact by including a few darker distant figures directly behind, which, together with a strong colour accent of bright red on the figure itself, helps to lead the eye towards it.

Lincoln Road Mall, Miami, USA
35 x 56cm (14 x 22in) on 640gsm Rough surface Fabriano paper

Creating Expression with Light

In spoken language, expression is generated by phrasing or tone of voice. In the language of painting, expression is articulated by light; at no time is this more evident than in the depiction of the human face.

Producing a portrait

As with other subjects, expressive portraits are created from a collection of the usual characteristics: linear shapes, patterns of forms, design, movement and the use of tone and colour. The way in which we use light to bring these elements to life enables us to show something of the variety of underlying moods, thoughts or feelings that are revealed by the slightest changes in facial expression and to which we instinctively respond.

Layout drawing

For this example, I chose to work on Bristol Board because I wanted the vitality of the brush marks and runbacks to be evident in my final painting. I began by making a profile drawing using a 4B pencil, observing the subject in a more abstract, less subjective way, I visualized forms reduced to an assortment of (less recognizable) positive and negative patterns of shapes. At this stage, I concentrated only on producing a linear outline of the subject, drawing as accurately as I could.

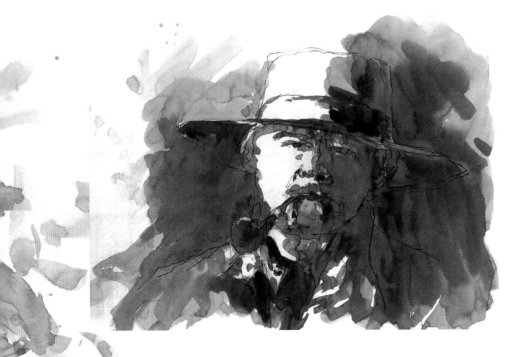

Tonal rough

To help me determine the overall lighting pattern for the painting, I produced a preliminary tonal rough using Lamp Black watercolour. I worked on a photocopy of my original drawing for simplicity. This also helped me to clarify which parts of the painting were to be the more dominant focal elements and which areas might then be subordinated. The angle of the lighting, from left to right, created a distinct pattern of light and shade across the head, breaking the subject down into well-defined, directly lit, shaded and shadowed planes. The sharp lighting contrasts on the left side of the subject's face and eye made these the more natural focal features. I began by painting these elements first, working around the lights, combining hard edges and strong tonal contrasts. Tonal studies also enable you to explore where edges of supporting forms might be lost, or their junctions softened. At this stage I felt that, to retain the focal features in the face, I needed to reduce the impact of the rest of the image. Therefore, in places, I linked adjacent areas of the head, hat and background, painting across the forms in the same tonal values. I felt there might also be the opportunity to do this across the edges of the shoulders. Although the temptation is to produce a tonal rough as a completed painting, its purpose is only to resolve the general lighting arrangement and provide a more certain foundation for subsequent applications of colour in the actual painting.

Start with the focal features

I often begin a painting working out from the focal feature; here, I began with the left eye. I used Burnt Sienna and Ultramarine Blue for the dark iris, with mixtures of Cadmium Lemon Pale, Raw Sienna, Cadmium Red Light and Cerulean Blue for my main flesh tones. I laid colours next to each other and allowed them to blend together as I progressed.

Build up the shapes

I continued to use separate individual touches of both warm and cool flesh-colour mixes, cutting around the highlights. I cooled the flesh colour around the eye with Cerulean Blue and painted the nose with Cadmium Red Light and Cadmium Lemon Pale, softening off the hard edge along the length of the nose. I cooled the shadow underneath it with Cerulean Blue and Raw Sienna and also began to define the mouth.

The excitement of watercolour lies in creating dramatic contrasts between the white paper and darker, directly applied, areas of colour. As the painting progressed, I continued to match the values of my colour mixes to the areas in the tonal rough, incorporating hard and soft edges where appropriate.

Paint out of the forms

I ran the edges of the face into the adjacent forms of the underside of the hat and background, pulling in Ultramarine Blue and Burnt Sienna, which I continued under the chin into the shirt and jacket. I added in the shadow of the pipe on the lip and chin with Cerulean Blue and Raw Sienna. At this stage I was anxious to retain the fluidity of the image.

Keep everything moving

As I progressed the image, I tried to keep all the areas of the painting moving along together, while judging what I was doing in relation to the focal features. To define the lit side of the face, I laid in the left background, adding a touch more Burnt Sienna in the general area of the hat. I also began to describe the shape of the upper part of the hat, while keeping it understated.

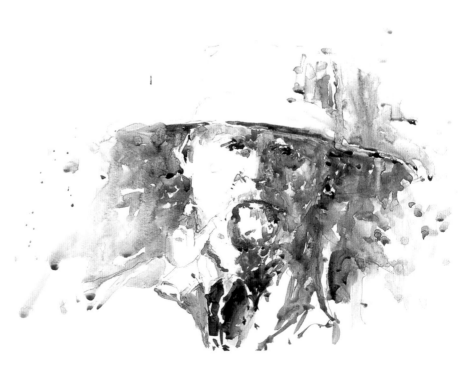

Finished painting

To complete the painting, I added the eyebrows, nostrils and included
a little more definition under the chin. I drew in the pipe with Burnt
Umber and Ultramarine Blue, keeping it hard-edged to bring it forward.
I also slightly sharpened the line of the hat brim and added a little more
definition to the top. The lost and found edges help to create additional
rhythm and movement.

George
30 x 42cm (12 x 17in) on
250gsm Bristol Board

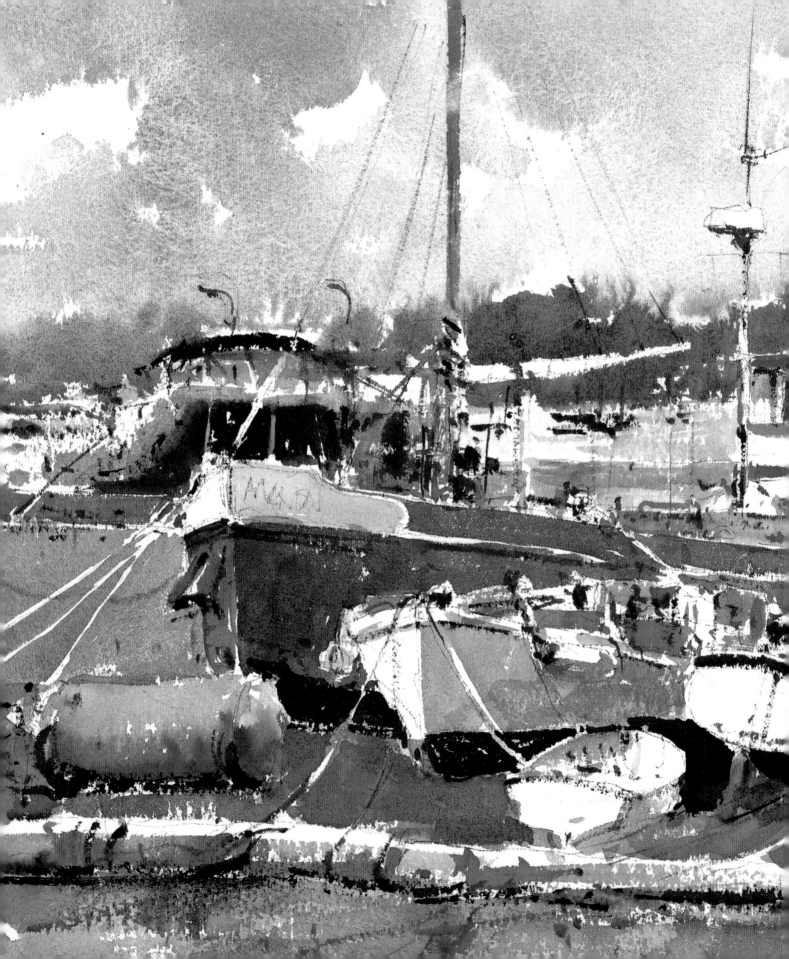

Chapter 8
Conclusions

The route towards a more personal way of painting will be a continuous journey of exploration. Sometimes the road will be clear, but more often you will have to travel your own path. The directions lie in the paintings you produce, so you must learn to look at them objectively. This will enable you to become your own teacher, recognizing what you do well and also identifying those areas that you consider to be in need of improvement.

Boats at Pin Mill
30 x 40cm (12 x 16in) on 300gsm Rough surface Arches paper

Furthering Personal Expression

How we express ourselves inevitably forms the basis of our painting style. Yet having stated in the introduction to the book that striving for any manner of distinctive painting style would be counterproductive, what we have to consider now is whether there are any steps we might take to help us along our own natural path.

Letting go

Since all paintings begin with thinking, having a positive mental attitude is always a worthwhile aim. This will go a long way to ensuring that you are in a receptive frame of mind for finding new opportunities, or trying out new approaches. Some of the most common negative attitudes are anxiety, pressure to succeed, fear of failure, impatience and having rigid ideas. Although it is inevitable that, from time to time, we will all suffer these feelings, prolonged negative attitudes act as barriers that can prevent us from producing our best work. To paint well, we need to be calm, letting go of apprehension and working with an almost carefree approach, rather like a child at play. Like many other creative processes, the painting seed takes its own time to flower, so I suggest that you don't cling to inner expectations of producing amazing results. The quality and individuality of your work will develop slowly as you do more and more painting. Let this happen as a gradual process, otherwise you may be building yourself up for continual disappointment.

The Harbour
30 x 40cm (12 x 16in) on 300gsm Rough surface Arches paper
When painting intuitively, do not try to reason why, simply do whatever feels right. Here I limited my colours to orange, violet and green, because I felt this would give a fairly monochromatic appearance of looking against the light. I mixed my colours intuitively, making marks rather than trying to paint specific 'things'

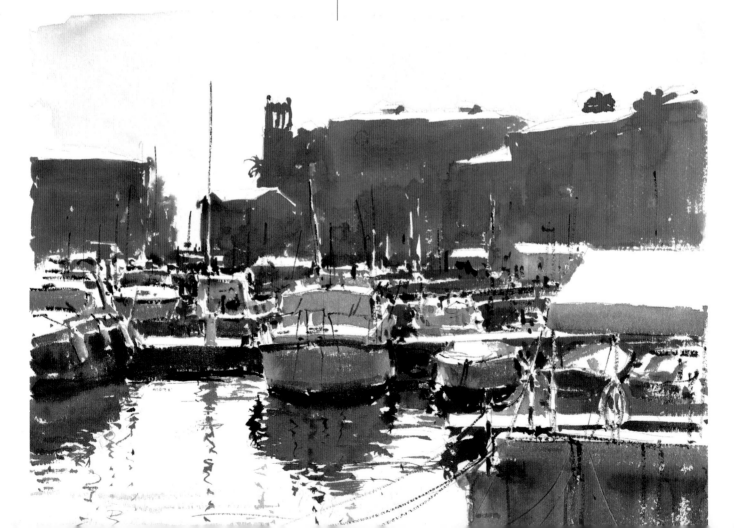

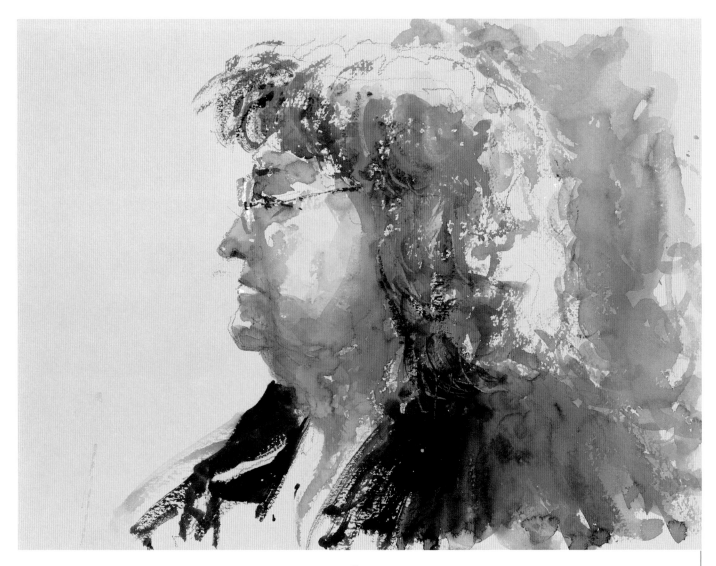

Working intuitively

Having a positive mental attitude can also allow us to work in a more intuitive way. This means doing what we *feel* to be right, rather than what we know by reason. The expression 'going with the flow' perhaps best sums up this approach, because creativity relies largely on instinct rather than intellect. It is impossible to do this if you are constantly trying to judge the quality of what you are producing. The two activities are mutually exclusive and should therefore always be separated. Allow yourself breaks in your painting times to step back and consider what you have done so far. Look at the painting while you are relaxed, to decide what might be needed when you go back to it. If you are unsure, turn the painting upside down, look at it in a mirror, or put it away for a few days; this will enable you to see it with a fresh eye. The important thing is to only make changes if you instinctively feel them to be right. When you continue, remember to continue working intuitively as before.

Taking risks

Attempting new things will always bring with it a degree of uncertainty, which usually means you are engaged in a learning process. But to get the most from painting you have to be prepared to take some risks, rather than remaining within the safety and security of what you may have done previously. This approach may end in failure, but alternatively it could open a door to a fresh way of working. Had you not been willing to step outside your comfort zone, this may have remained simply as a lost opportunity.

Pearl
28 x 38cm (11 x 15in) on 300gsm Rough surface oatmeal-tinted Two Rivers paper
Don't let chance encounters pass you by – they can expand your horizons. I produced this image of one of my fellow artists towards the end of a day's life drawing, when I was beginning to struggle with working from the actual model. I limited my colours to Burnt Sienna and Lamp Black

Adding some Verve

Paintings produced in circumstances or under conditions that are different to what we are used to can be both challenging and provide further opportunities for experimentation.

Working against the clock

The saying that work expands to fill the time available may also be true for painting. Setting yourself a time limit is therefore a worthwhile expedient, because it will force you to be more decisive. This doesn't necessarily mean rushing a painting; it is more to do with having to work with greater efficiency. Whenever time is at a premium, your concentration, by necessity, will focus on the essentials of your subject. This probably means that you will have to considerably play down or leave out everything else. This process often works best when you are 'tuned in' to your subject, towards the end of a day's painting. The painting right shows one of several quick studies I produced as warm-ups at the beginning of a day's life drawing. In these circumstances, there is very little time to worry about anything other than getting the essence of the subject down as quickly as possible, before the time elapses. Paintings produced under such conditions will often show economy of line and form and will convey a resourceful and more confident and inventive representation of the subject.

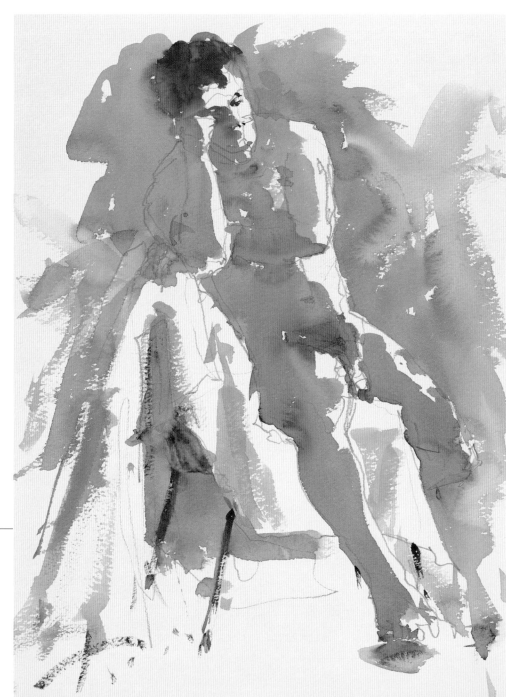

Male Nude
36 x 28cm (14 x 11in) on 300gsm Not surface cream-tinted Bockingford paper
I produced this image during a six-minute time-constrained pose, so it was something of a race against the clock. I rapidly sketched in a pencil outline and used a warm/cool colour palette of Burnt Sienna and Lamp Black to depict the effects of the light across the figure

Using exotic colours

In Chapter 4 I touched on how colour can be used to create more personalized images. In this case, how a specific group of unusual colours (that is, unusual in how they were used in relation to that particular subject) can be combined to provide an alternative interpretation. I want to extend this thinking into combining groups of more exotic colours, those that might at first seem out of place. Choice here could be made on the basis of favourites, rather than because colours suit the particular subject, or by selecting combinations of unrepresentative, more striking colours. In the painting right, I decided to see what might be achievable using a group of four fairly intense and rather brash colours. Such an experimental approach may provide some surprises and is a valid way of extending your individual colour repertoire.

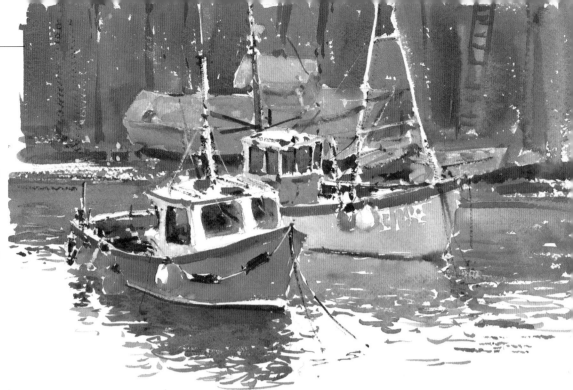

Boats at Bridport
28 x 38cm (11 x 15in) on 300gsm Rough surface Fabriano paper
This is a painting of the image I used on page 34. Compared to the original, here I used a fairly bizarre combination of colours, namely Cadmium Orange, Cobalt Violet, Caput Mortum Violet and Viridian. I mixed my colours intuitively, while matching the tonal values of the mixes to the corresponding values of the subject

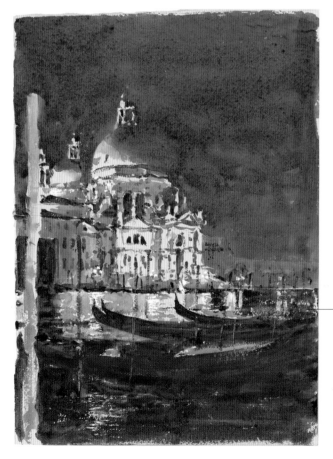

Painting night scenes

Painting night scenes can be an invigorating experience and has the potential to produce some interesting results. The overriding difficulty to overcome is adjusting your eyes so that you can see the colours and tones of your subject, while at the same time having enough light to judge the colours and tones in your painting. Night photographs cannot be relied on to give a true interpretation, since they will never be quite what you see in reality, either being under- or overexposed in places. Limiting 'on the spot' activities to drawing is probably best, blocking in a range of tones to record the general lighting pattern. A convenient method is to work on a mid- to darker-toned paper, adding back the lightest lights with white chalk. The most effective night images contain dominant areas of artificial light that conveniently act as focal features. I produced the painting left in the studio, working from an 'on the spot' drawing and a couple of night-time photographs. I used a buff-coloured tinted paper, which was almost a match for the lightest areas of the building, and I added back my lightest lights with white gouache.

The Salute at Night
38 x 28cm (15 x 11in) on 300gsm Rough surface
cream-tinted Two Rivers paper
Much of this image was to be in the lower tonal register. To prevent the darks appearing dull and lifeless, I mixed them from combinations of Alizarin Crimson, Viridian and a touch of Burnt Sienna to give them energy. For the warmer-coloured buildings and foreground features, I used Alizarin Crimson, Ultramarine Blue and Raw Sienna

When is a Painting Finished?

Many watercolours fail as a result of having the life painted out of them. The borderline between finishing a painting and finishing it off is often quite narrow, so knowing when to stop is a crucial step in the painting process.

Working economically

In my introduction to this book I suggested that watercolours should aspire to catch the moment. The most effective way of doing this is to work with economy of means, because the extravagance of overworking can so easily reduce even the best-laid plans to insignificance. Every painting will, of course, be different, so deciding when any is complete has to be a matter of individual judgment in each case; it is virtually impossible to predict. Generally, it is always a good idea to stop before you think a painting is finished; you will then be less likely to tinker with it. If you become conscious of doing this, stop immediately, because at this stage, the painting will more than likely already be complete and you will be in real danger of overworking it. I think it is worth mentioning here that neatness and tidiness are an anathema to painting, so do avoid the habit of fiddling with an image when completed in some vain attempt to improve it. If you begin with a clear idea of what it is about your subject that you wish to convey and keep this in mind during the painting process, you will be in a better position to know when you have achieved it and thus when to stop. Sometimes all a watercolour needs are a few well-placed brush marks to convey its message. It isn't necessary to feel that you have to spend hours toiling over a painting for it to be worthy of being thought of as finished. In the painting below, my aim was to record the light across the building.

Church at Higham on the Hill
29 x 40cm (11½ x 16in) sketchbook study
Sometimes an image needs just a few touches in order to catch the moment. I limited my painting here to only the shaded sides of the building and cast shadows. Although much of the picture surface remains as white paper, enough had been done to convey my original intentions

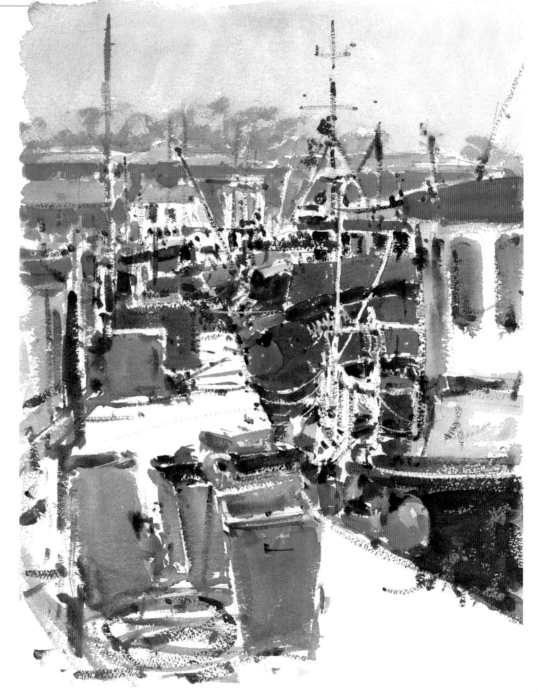

Quayside
40 x 30cm (16 x 12in) on 300gsm Rough
surface Arches paper
*Once the focal feature in a painting
has been established, the remaining
elements can be left as understated
supporting shapes, as I have done here*

Retaining awareness

Inevitably paintings will change to
some degree as they proceed, so
always try to remain aware of this
possibility. Often the marks you
make will suggest further steps that
are not completely in keeping with
your original plan, or what may
have begun as a promising idea
starts to appear lacklustre during
the painting process. This is quite
normal, although the danger here
is of falling into the trap of seeing
problem areas in isolation, which
you then resolve separately. Always
keep your eye on the painting as
a whole and make any changes in
relation to the complete picture. In
the painting right, I began with the
intention of making the boats, in
general, and the second (blue) boat,
in particular, my focal feature. I
painted this first, cutting around the
lighter shapes of the nearer boat as I
went. When I placed in the group of
foreground bins, these appeared to
make a more natural focal feature.
So I altered course and left the line
of boats and everything else in the
image more understated than I had
originally intended.

Final thoughts

Watercolour painting can be an exhilarating and fulfilling
experience, with the potential to provide a lifetime's pleasure. It
can also be unpredictable and extremely exasperating, often with
an apparent will of its own. But no matter how uncertain the way
forward, success lies in never, ever, giving up the journey.

About the author

Gerald Green was born in Nuneaton, Warwickshire, in 1947. In 1987 he gave up a career as an architect to become a full-time artist and illustrator. He soon gained a reputation as one of the UK's leading architectural illustrators, numbering several major national and international companies among his many clients.

Gerald now devotes himself entirely to painting. His work has been shown in numerous public and private galleries in the UK, and he has been a finalist in several national arts competitions, including The Sunday Times Watercolour Competition, The Laing and Not The Turner Prize exhibitions, together with various Society shows at the Mall Galleries, London.

Gerald occasionally teaches at residential workshops and has worked with a number of Art Societies. He is a regular contributor to arts magazines, including *The Artist* and *International Artist*. His work can also be found in eight other books.

More information about Gerald's work can be seen on his website: www.ggarts.demon.co.uk

Acknowledgments

I should like to offer my special thanks to Freya Dangerfield at David & Charles for her continued help and encouragement during the developmental stages of the book, together with Emily Rae and Sarah Underhill for their hard work in translating my words and images into this book. Also not forgetting my wife Diana, for her support and supply of endless cups of coffee.

End Papers (front)
Rialto Bridge
30 x 40cm (12 x 16in) on 300gsm
Rough surface Arches paper

End Papers (back)
Children's Bikes
27 x 21cm (10½ x 8in) on 300gsm
HP Saunders paper

2008, July.18

FtW

22,99

169241